CHRISTMAS
ON
NANTUCKET

By Leslie Linsley

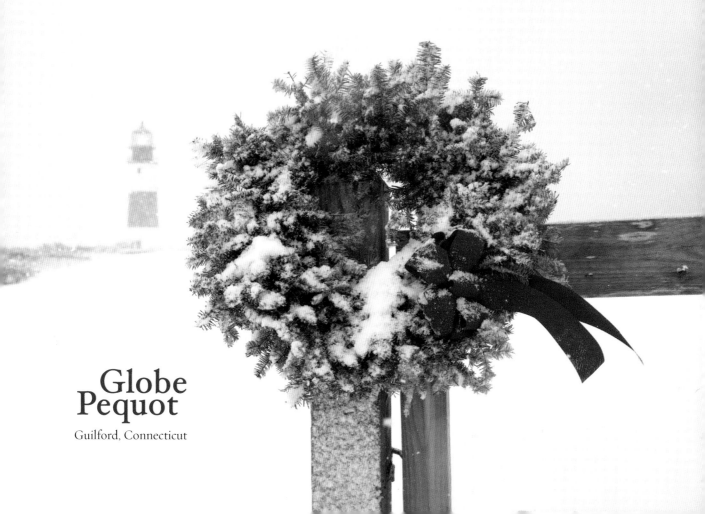

Globe
Pequot
Guilford, Connecticut

Globe Pequot

An imprint of The Rowman & Littlefield
Publishing Group, Inc.
4501 Forbes Blvd., Ste. 200
Lanham, MD 20706
www.rowman.com

Distributed by NATIONAL BOOK NETWORK

PHOTOS BY JEFFREY ALLEN with the following exceptions:
JON ARON—pages 4, 5, 34, 35, 36-37, 40-41, 50-51, 52-53,
54, 55, 64, 68 (top), 69, 70, 130
CARY HAZLEGROVE—pages i, v, 2, 11, 13, 20-21, 29, 31, 32-33,
39, 44 (bottom), 46-47, 48-49, 56-57, 58, 101, 128 (top)
TERRY POMMETT—pages ii-iii, 3, 16-17, 18, 19, 38, 80.

British Library Cataloguing in Publication
Information available

**Library of Congress Cataloging-in-Publication
Data available**

ISBN 978-1-4930-4494-8 (hardback)
ISBN 978-1-4930-4495-5 (e-book)

♾™ The paper used in this publication meets the
minimum requirements of American National Standard
for Information Sciences—Permanence of Paper for
Printed Library Materials, ANSI/NISO Z39.48-1992

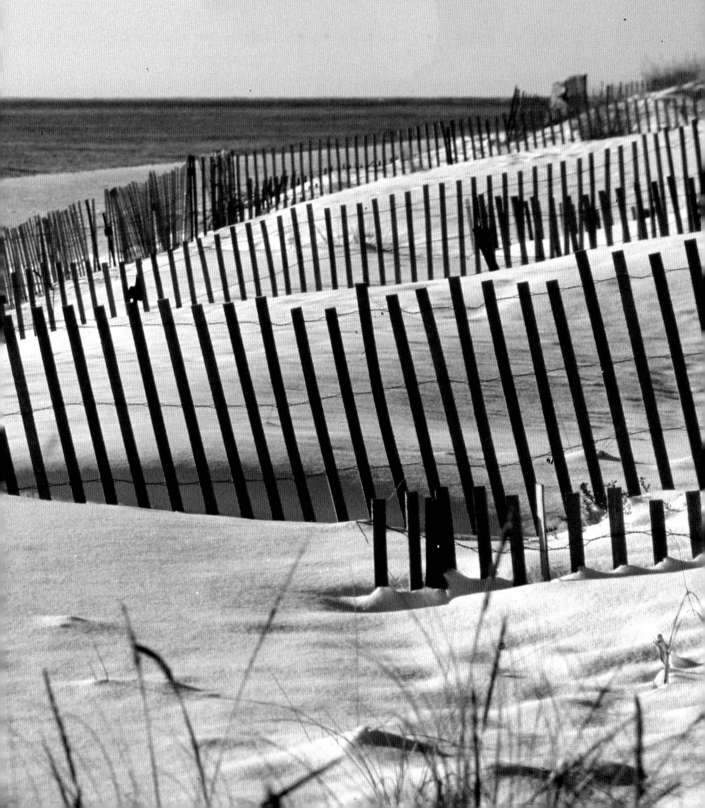

For Jon Aron, my longtime partner in work and life.

We had the best time ever!

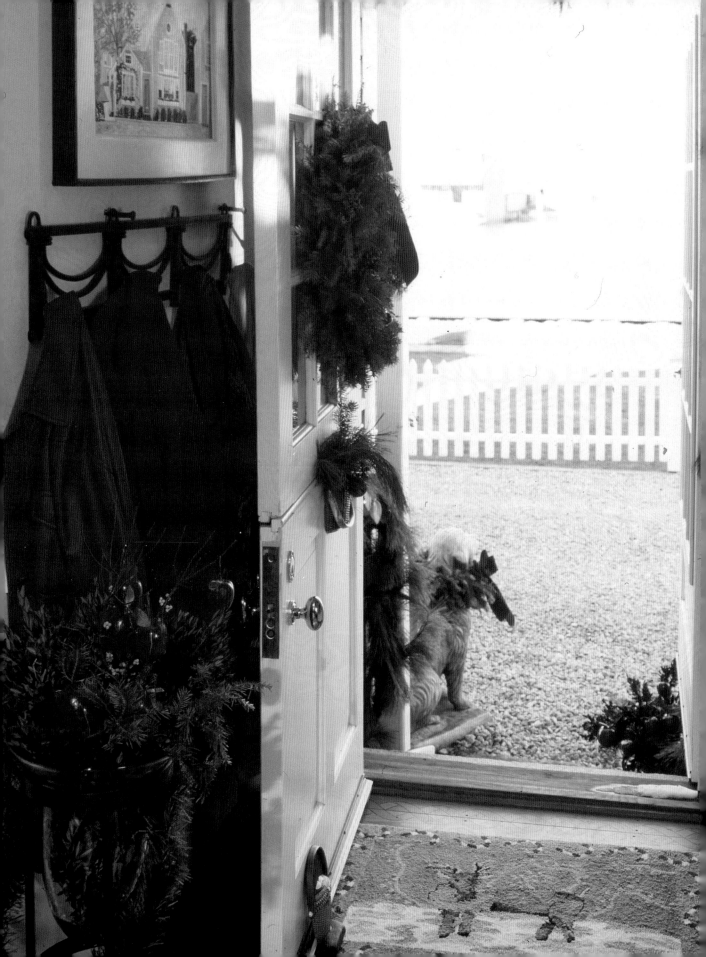

CONTENTS

Christmas on Nantucket 1

A Christmas Stroll Around Nantucket 21

Deck the Doors 61

Christmas in Island Homes 81

Personal Pleasures 93

Holiday Entertaining Nantucket Style 119

About the Author and Photographers 130

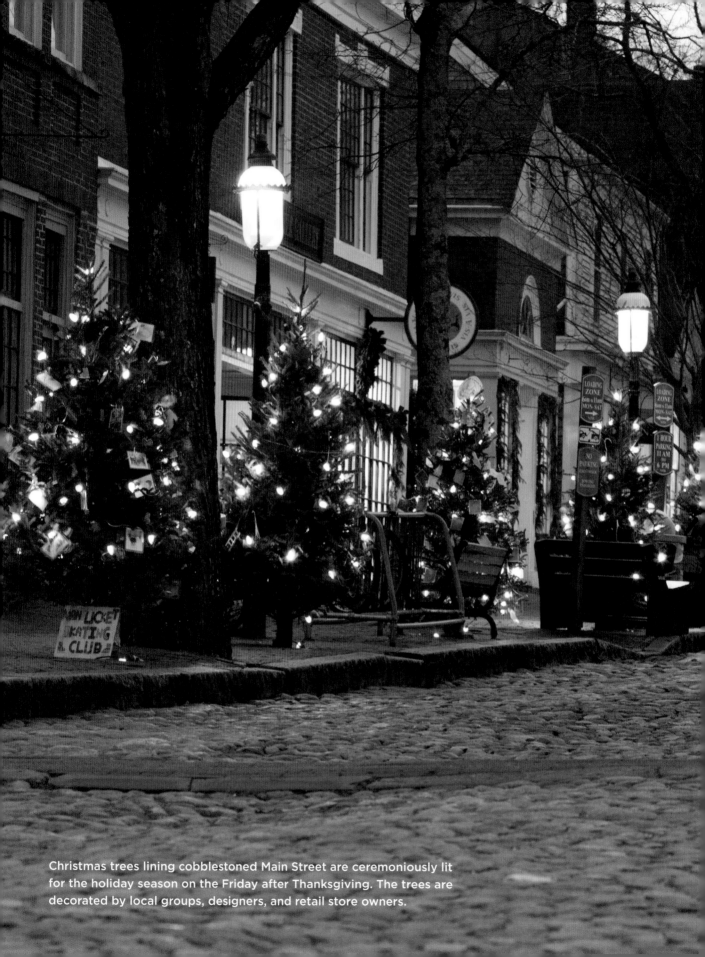

Christmas trees lining cobblestoned Main Street are ceremoniously lit for the holiday season on the Friday after Thanksgiving. The trees are decorated by local groups, designers, and retail store owners.

CHRISTMAS ON NANTUCKET

Many people have favorite memories of Christmas from when they were children, or of a gift that truly surprised them. Many of us are nostalgic for Christmases past. I live on Nantucket Island, where December has to be the prettiest time of year, when the island looks like an old-fashioned Christmas card. Islanders take special care to decorate their homes with traditional bowers and garlands of evergreens, holly, winterberries, seashells, and pinecones, all part of the island's natural bounty. At this time of year the island is transformed into a holiday wonderland. The trees on Main Street are lit and the harbor is aglitter with boats decked out with lights or perhaps a little tree decorated and sparkling on the bow. The galleries and shops on Straight Wharf and Old South Wharf are outlined with tiny clear lights and the lanterns are strung with greenery and red bows. The shops in town are decorated as well and Main, Centre, Federal, and India Streets are lined with Christmas trees uniquely decorated by island groups, stores, and classrooms and ceremoniously lit at sundown on the Friday after Thanksgiving. Nantucket is ready to extend a traditional welcome to islanders and visitors who come to join in our Christmas Stroll, always the weekend after Thanksgiving.

"OVER THE RIVER AND THROUGH THE WOODS, to grandmother's house we go" is an old refrain that evokes images of Christmas from long ago. And although we no longer travel by horse and buggy (except when Santa and Mrs. Claus arrive by boat and then ride in a horse-drawn buggy over the cobblestones to the top of Main Street), we still maintain many of the traditions associated with the past, especially those of small towns throughout the country. Perhaps this is why our island has become such a popular place to spend the holidays.

THE BRANT POINT LIGHTHOUSE is one of three lighthouses on the island and has been protecting Nantucket Harbor since 1746. It sits on an accessible beach a short walk from town. As the steamship rounds the point, the lighthouse is the first historic landmark visitors see before entering Nantucket Harbor. There is a saying that goes, "If you throw a penny overboard as you round Brant Point, you will surely return to the island."

Brant Point Lighthouse greets visitors during the holiday season.

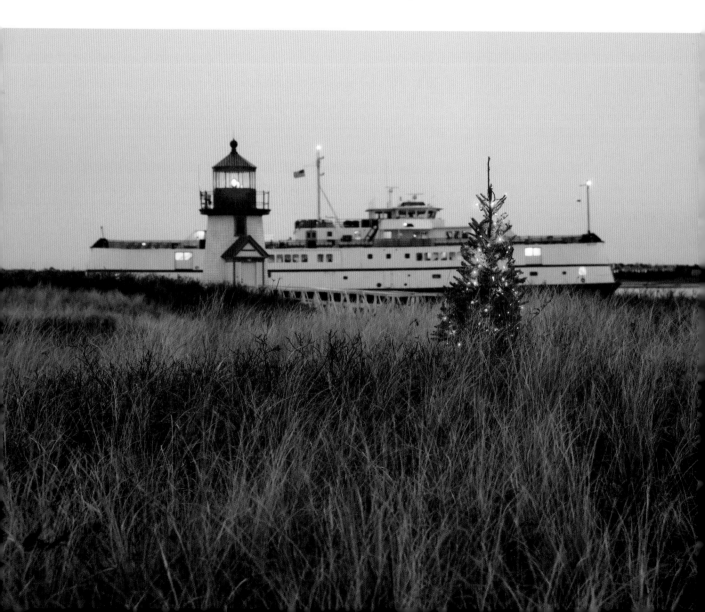

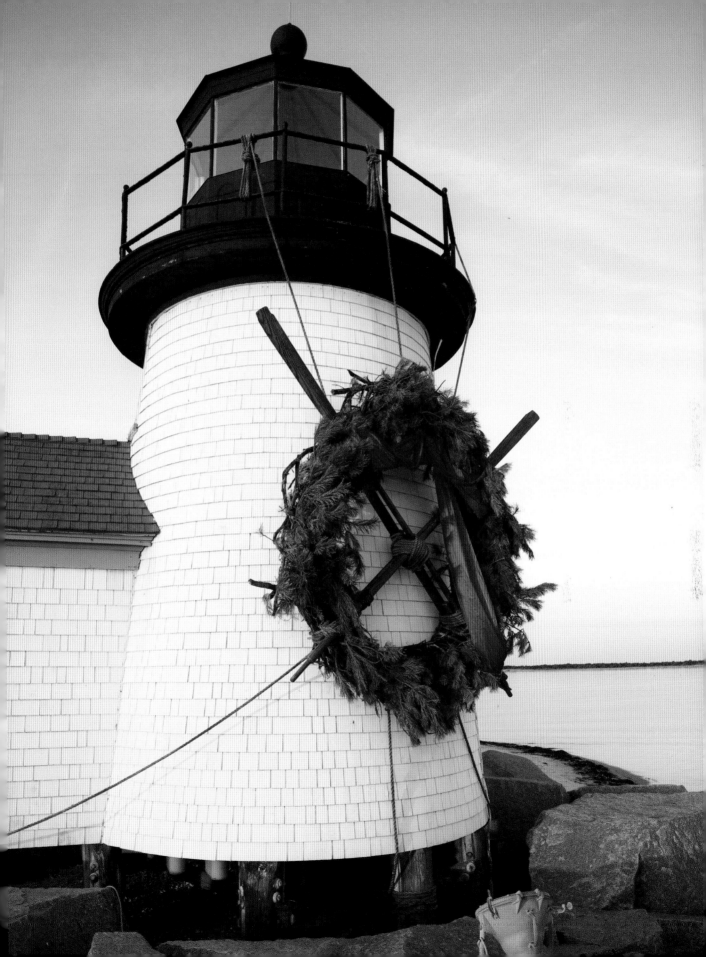

NANTUCKET IS A LITTLE PATCH of earth located thirty miles off the coast of Cape Cod in Massachusetts. The island can be reached by boat or by plane, and it is the isolation from the mainland that has been partially credited with keeping the island's natural beauty and charm intact.

Just seven miles wide and fourteen miles long, this little spit of land in the Atlantic Ocean has managed to achieve a level of sophistication that comes from adapting to whatever is new and elegant, while retaining an atmosphere of casual simplicity and its own historic traditions.

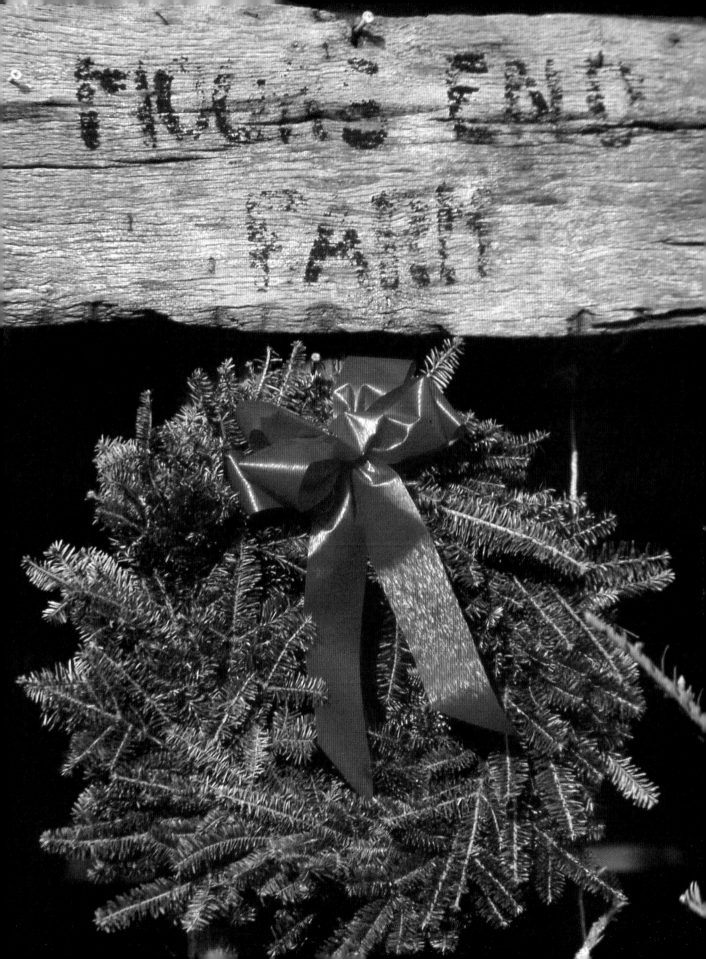

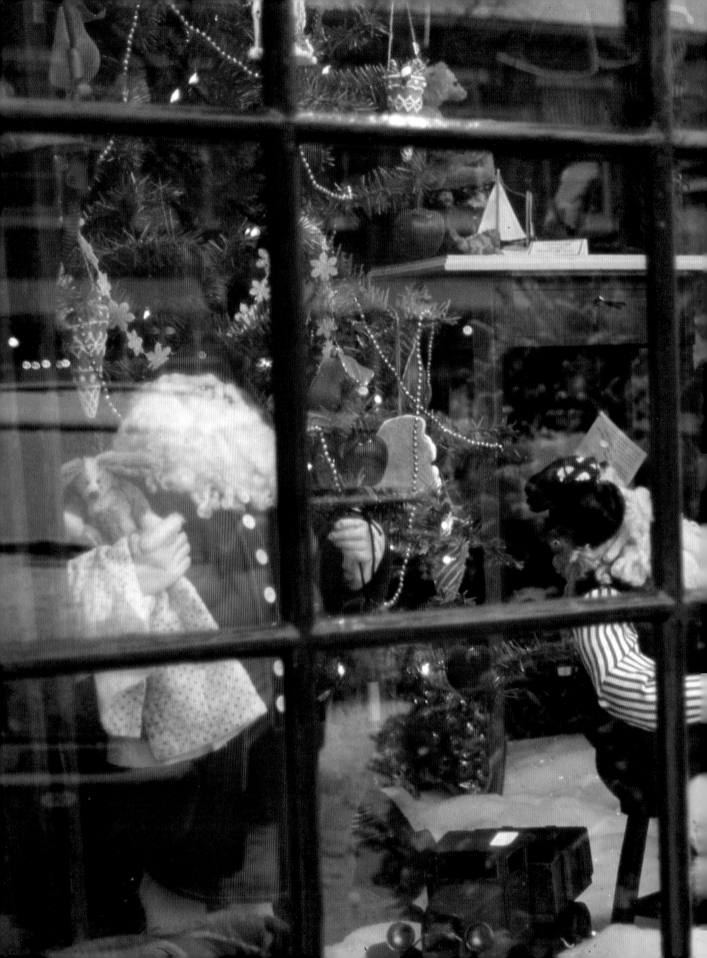

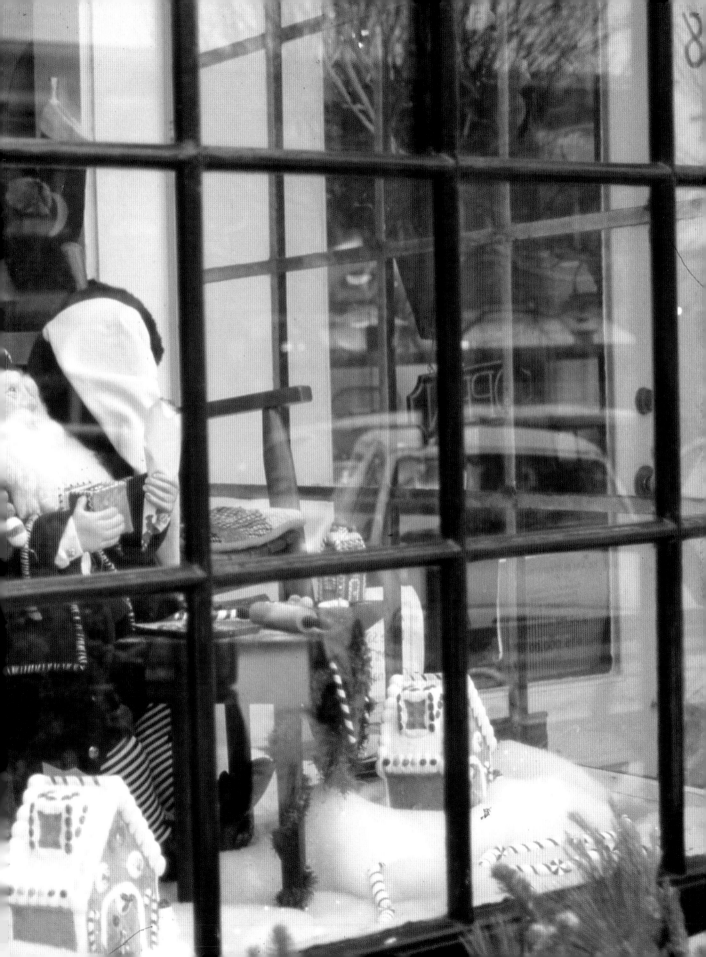

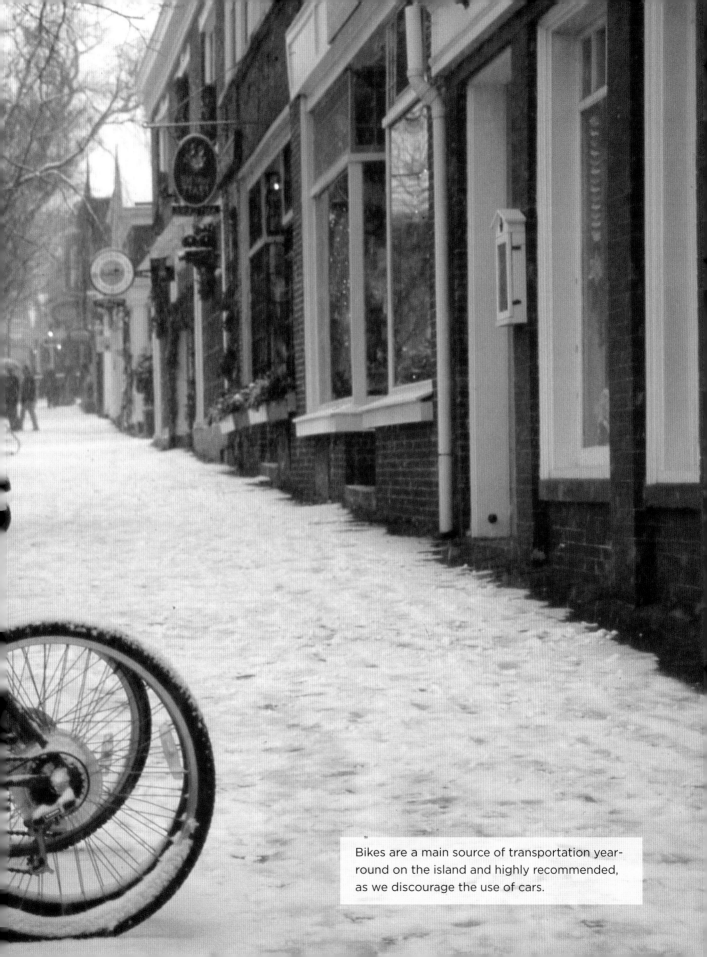

Bikes are a main source of transportation year-round on the island and highly recommended, as we discourage the use of cars.

CAPTAIN BARTHOLOMEW GOSWOLD, an Englishman, discovered the island of Nantucket in 1602. Thomas Mayhew later purchased it in 1641. For the next two hundred years the island population grew into an established, prosperous, and self-contained community. In 1712 the first spermaceti whale was caught, launching an industry that helped to make Nantucket known throughout the world.

Over the years there were many setbacks: The discovery of petroleum put an end to the need for whale oil, and the Great Fire of 1846 destroyed a third of the town. As early as 1870, with the island's population at an all-time low and not a ship to its name, some inventive people began to promote Nantucket as a tourist attraction, a place to enjoy the sea air and healthy environment.

Nantucket has since surpassed the wildest dreams of those first visionaries and is now a world-class summer resort. Today there are more than twelve thousand year-round residents on the island, and the population swells to more than fifty thousand during the summer months. However, while it is known as a summer vacation place, it is the off-season that islanders love best.

Nantucket is protected by the Gulf Stream and therefore rarely sees any snow. But with global warming, the island has had its fair share of snowstorms lately, which makes it all the more magical. Someone thoughtfully placed a wreath on the fence in front of Sankaty Lighthouse in the town of Siasconset.

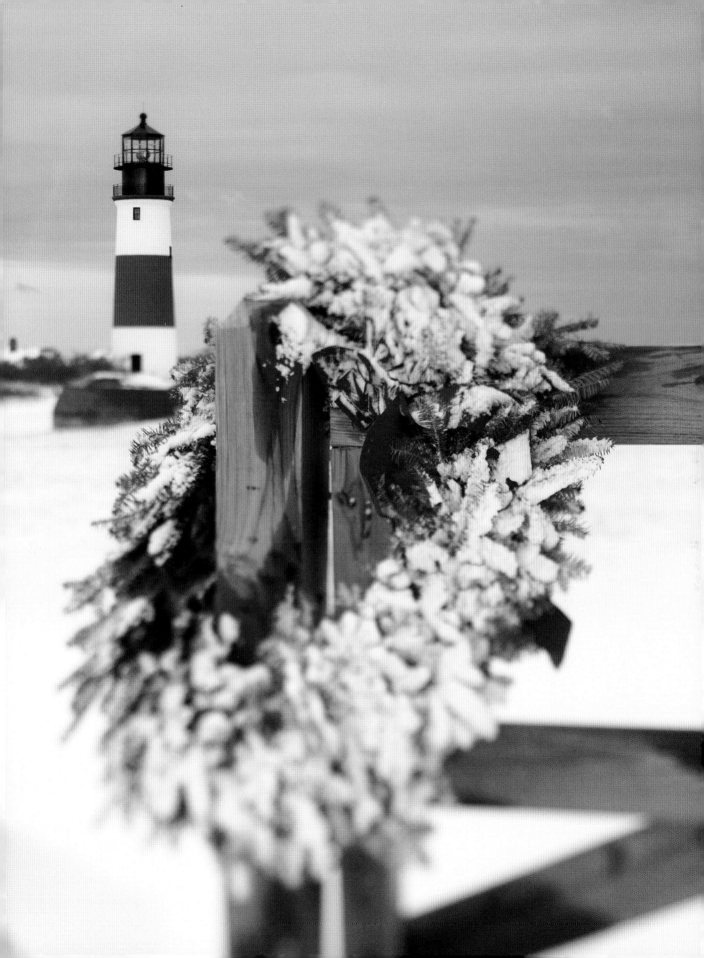

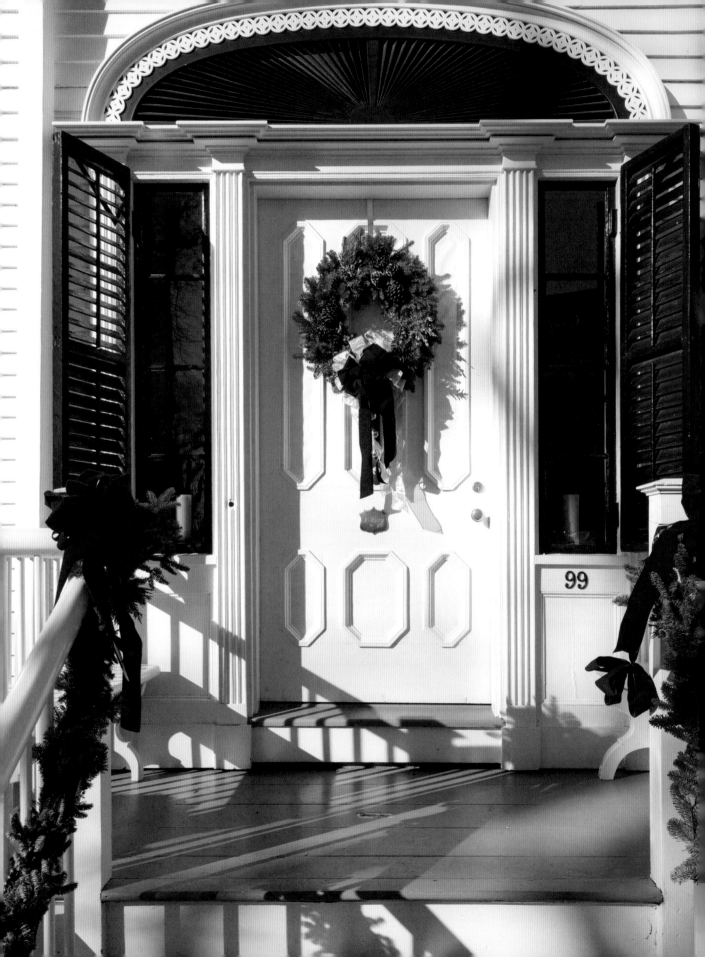

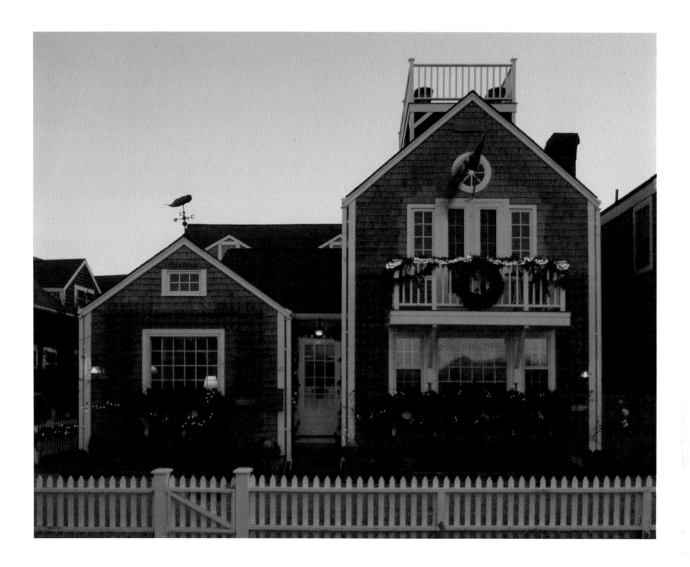

In the winter months the island's community spirit is more evident than at any other time of year. Islanders know, or at least recognize, one another and no one is in any particular hurry, always taking time to chat with an acquaintance when standing in line at the post office, stopping at the Hub for the paper, or shopping in the local supermarket.

Nantucket has been named one of America's endangered places by the National Trust for Historic Preservation. The houses in town were all built in the 1800s and have been inhabited ever since. The annual Holiday House Tour showcases houses beautifully decorated for Christmas, and gives visitors an opportunity to go into a select few of these private homes each year, some of which we have been fortunate to photograph for inclusion in this book. Many of the houses we photographed were chosen for their architectural and historic interest as well as for their special decorations.

LEFT: One of the early sea captain's houses on Main Street is decorated for the holidays.

NANTUCKET HAS ALWAYS STOOD FOR individuality and diversity in all things, and while many of the homes are antique, there are other, newer homes decorated in more contemporary styles. They are represented here as well.

To celebrate the creative spirit of the island each year The Nantucket Historical Association holds its annual Festival of Trees in the Whaling Museum. Designers, artists, and creative individuals design trees with an island theme to create a spectacular exhibit, filling this wonderful space with the romance and nostalgic qualities of Christmas in a quaint, historic village far from the commercial mainland locals refer to as "America."

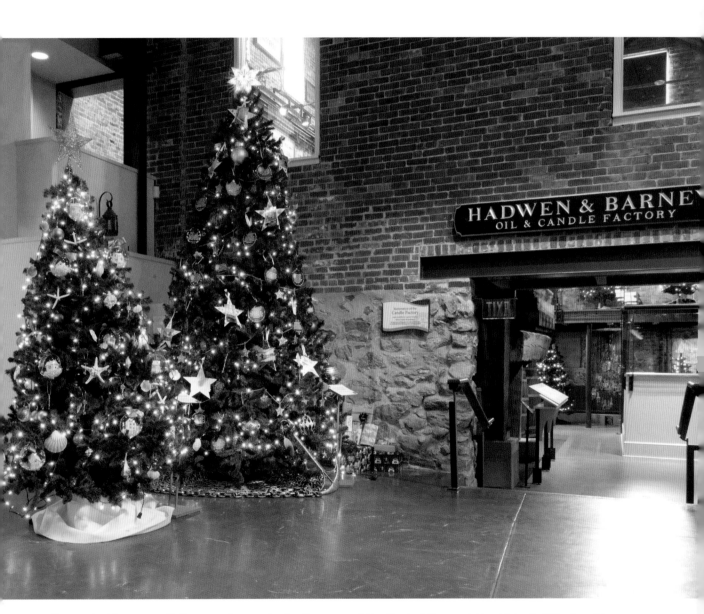

Decorated trees await the opening party for the annual Festival of Trees at the historic Whaling Museum on Broad Street.

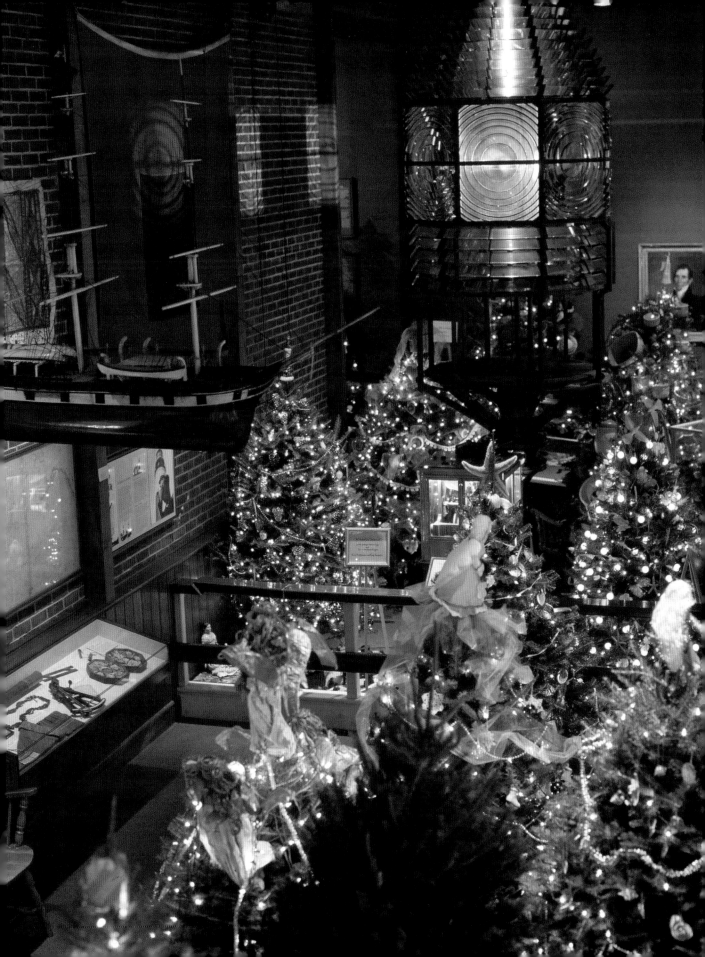

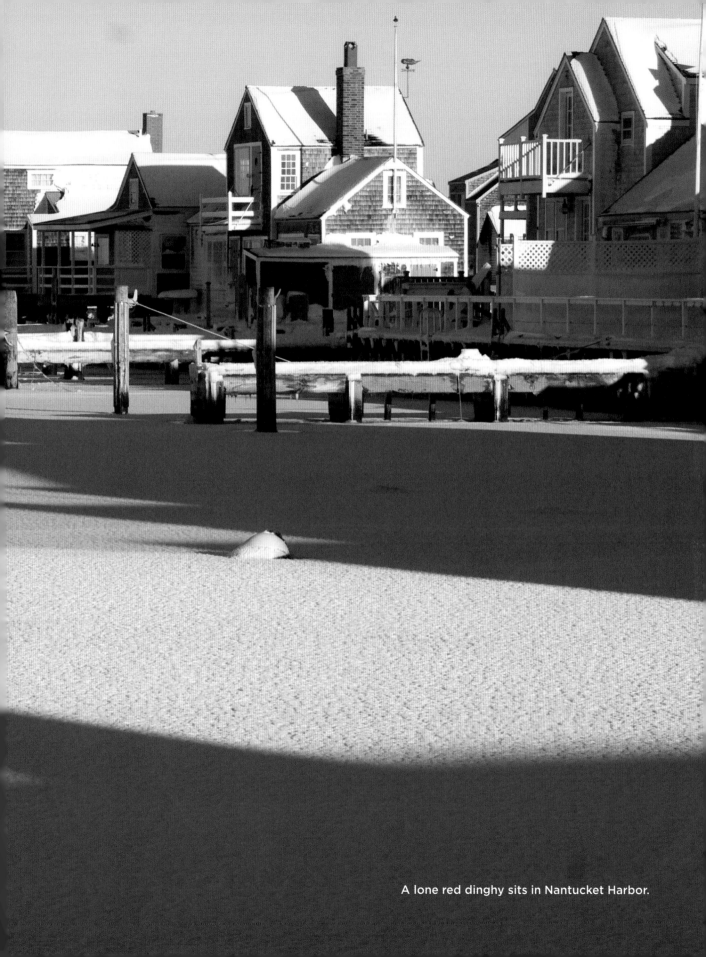

A lone red dinghy sits in Nantucket Harbor.

NANTUCKET IS MORE than a place—it's a state of mind. First-time visitors to the island are often struck by its physical quaintness and the charm and plainness of its Quaker-influenced buildings. Grey and weathered shingles, painted white trim, fences defining close-set yards, railed entrances, and twelve-over-twelve-paned windows typify island architecture.

Everything is in harmony and of a piece, and this has a calming effect on visitors who have left a more hectic world behind. There are no commercial signs or traffic lights, no visual or noise pollution. And so far, fast food chains haven't invaded the landscape, due to the determination of a watchful Historical Association.

And so, during this particularly beautiful time of year, we invite you to participate in island living through our eyes, whether joining us at the Festival of Trees or on a Christmas Stroll weekend, eavesdropping on a holiday party, or vicariously experiencing the magical qualities of our island.

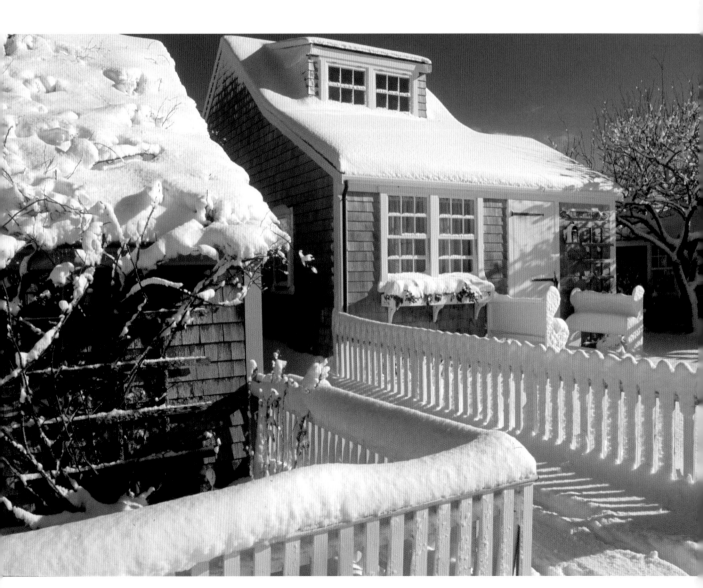

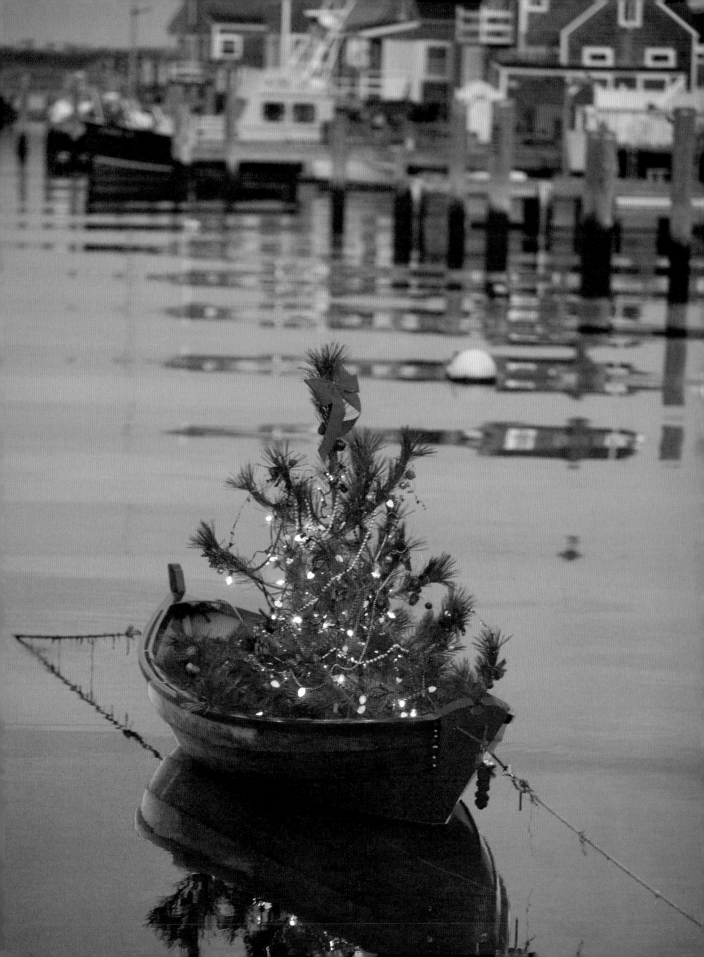

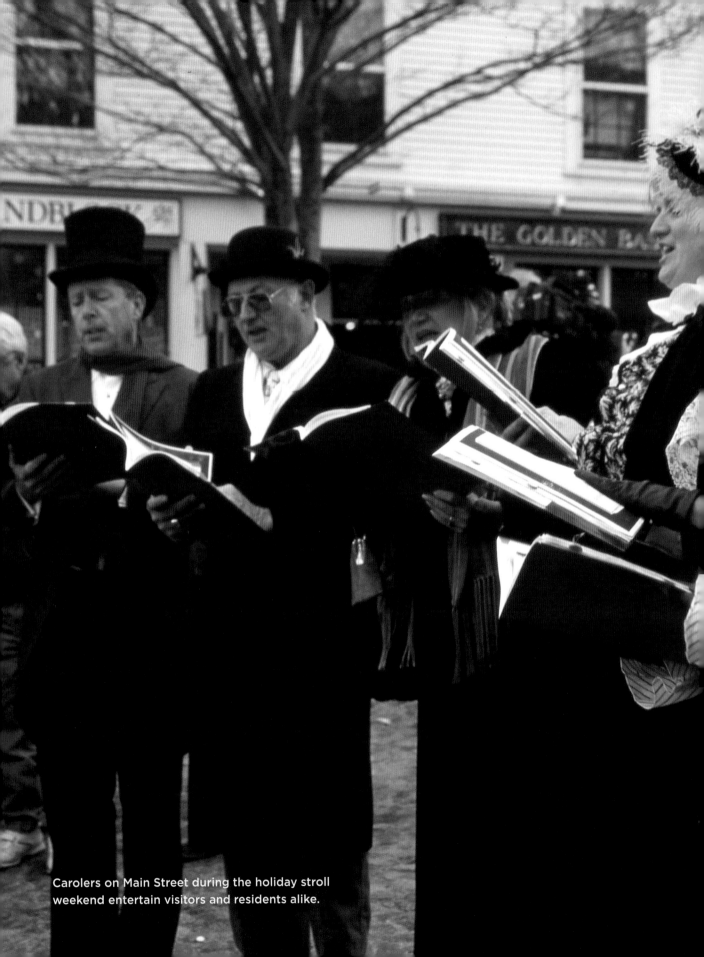

Carolers on Main Street during the holiday stroll weekend entertain visitors and residents alike.

A CHRISTMAS STROLL AROUND NANTUCKET

During the first week of December the Nantucket Chamber of Commerce puts on a festival that has traditionally drawn visitors to the island from all around the globe. Stores are decorated and serve hot cider and home-baked cookies, and local groups decorate the outdoor trees with a theme. Cobblestoned Main Street is cordoned off, allowing for pedestrians only, and there is much merriment with carolers. Santa arrives at the Nantucket Boat Basin via a Coast Guard boat, and travels via an antique fire truck (in the past Santa and Mrs. Claus arrived by horse and buggy) up Main Street to the Jared Coffin House and the hundreds of children lined up Broad Street waiting to meet him in the house's library. Holiday elves serve hot cocoa to the families waiting in line and many activities are offered to one and all.

On Nantucket much of the mainland commercialism passes us by. There are no malls, no chain stores, not even overhead stoplights, which makes it easy to concentrate on the spirit of the holidays—creating gifts and decorating our homes, visiting with friends, and, in general feeling a sense of community. Celebrating Christmas on Nantucket offers visitors a less harried alternative to today's often frenetic holiday season.

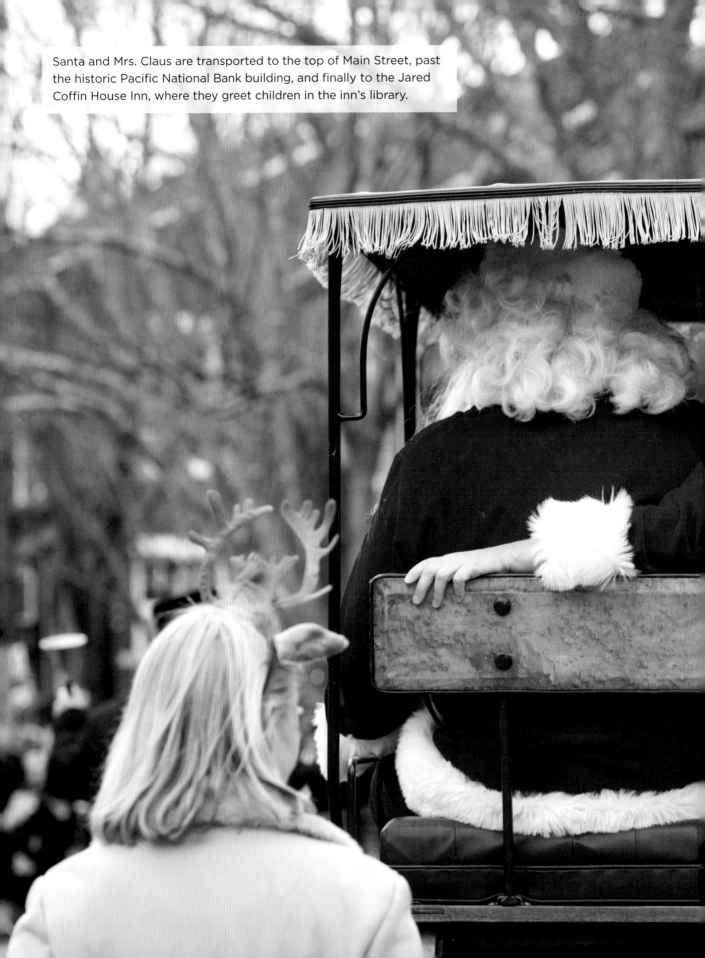

Santa and Mrs. Claus are transported to the top of Main Street, past the historic Pacific National Bank building, and finally to the Jared Coffin House Inn, where they greet children in the inn's library.

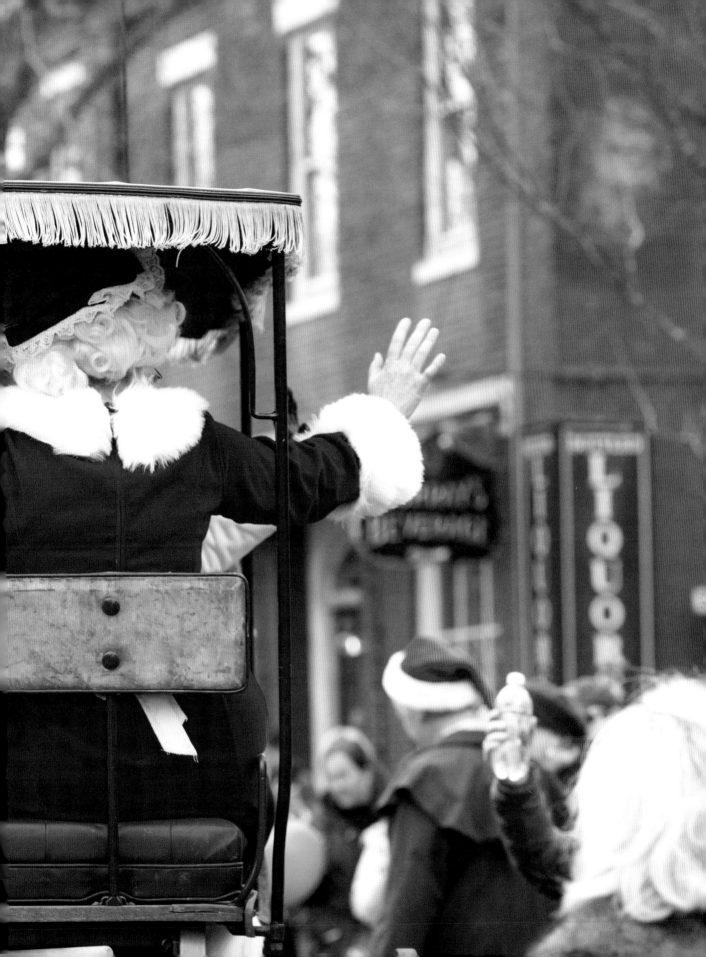

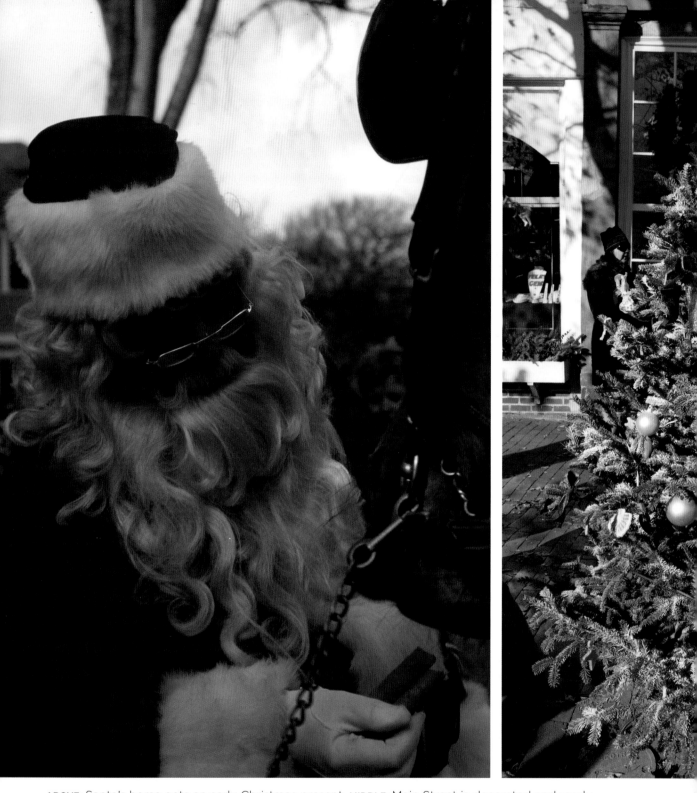

ABOVE: Santa's horse gets an early Christmas present. **MIDDLE:** Main Street is decorated and ready for the holiday season. Schoolchildren decorate many of the trees.

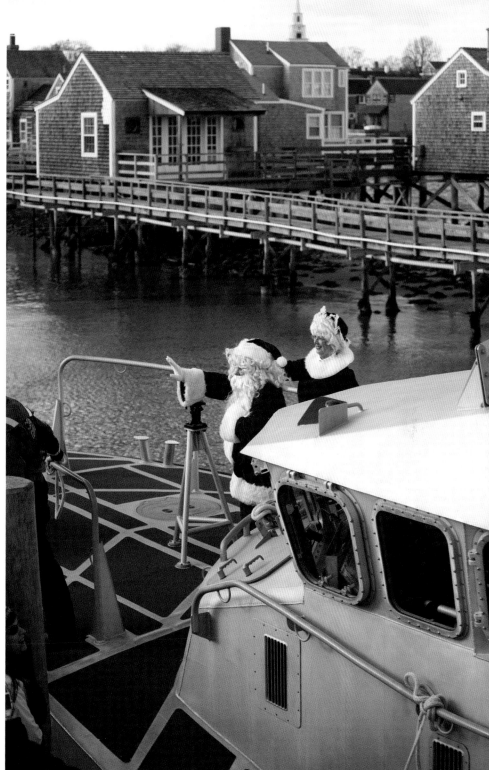

Mr. and Mrs. Claus arrive by Coast Guard Cutter into the harbor.

The little shops along Nantucket's streets and along the
wharves are decorated and open for Stroll weekend.

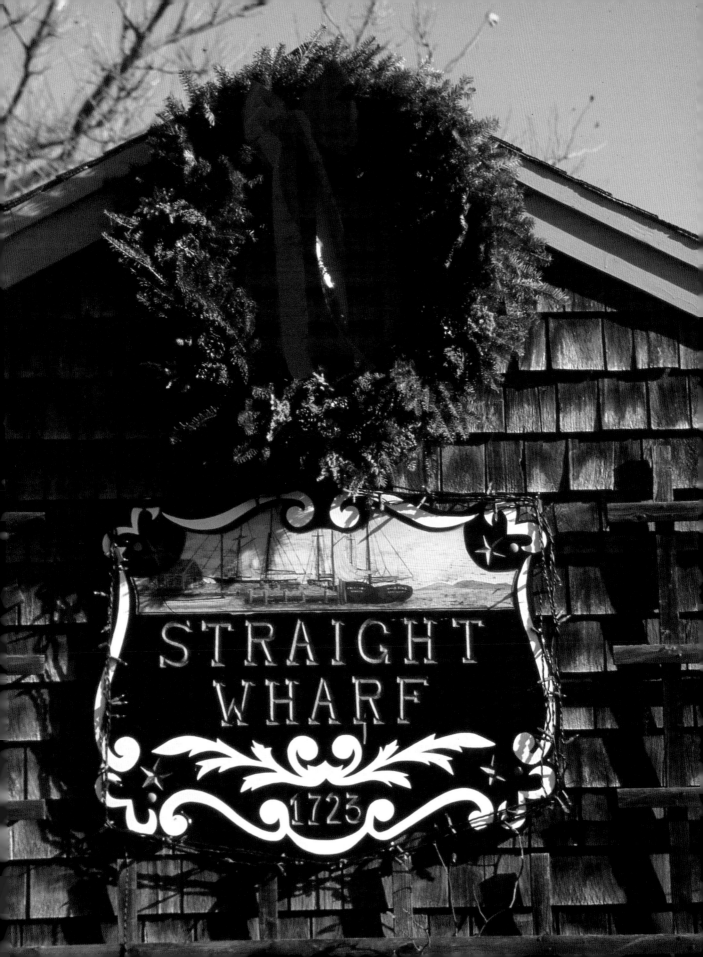

THE CHRISTMAS STROLL is for anyone who would like to experience the joy of the season in a small town. There are craft shows, art exhibits, raffles, carolers, theatrical performances, guided historical walking tours, dancers, bell rings, musicians, bazaars, a puppet show, food tents, and even a ghost walk. Yes, our old houses are rumored to have ghosts in residence. Many visitors who come here are nostalgic for what they may have had as children—or wish they had. Nantucket delivers the fantasy. It is also a way for many to give their children a sense of old-fashioned community celebration.

A concerted effort is made to maintain a level of quality throughout the island, whether in the stores, restaurants, hotels, or services, which makes this place so special year-round, but most certainly at this magical time of the year.

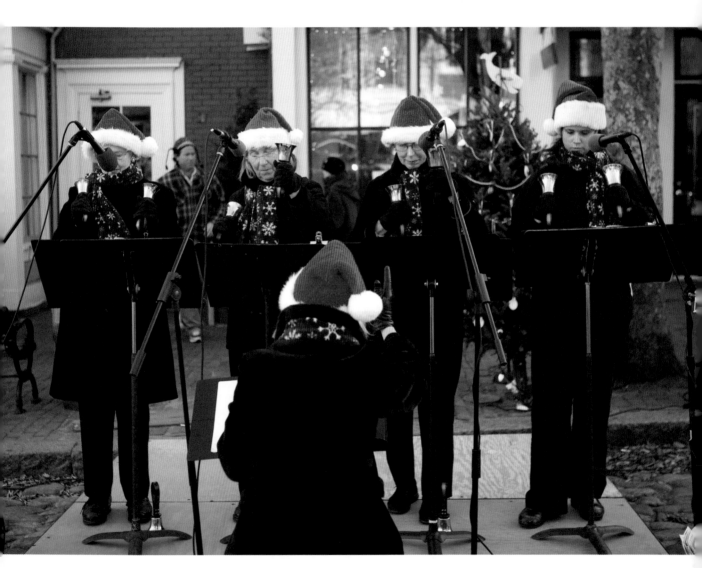

ABOVE: Carolers on Main Street entertain visitors. **RIGHT:** The monument at the foot of Main Street is decorated for the holidays.

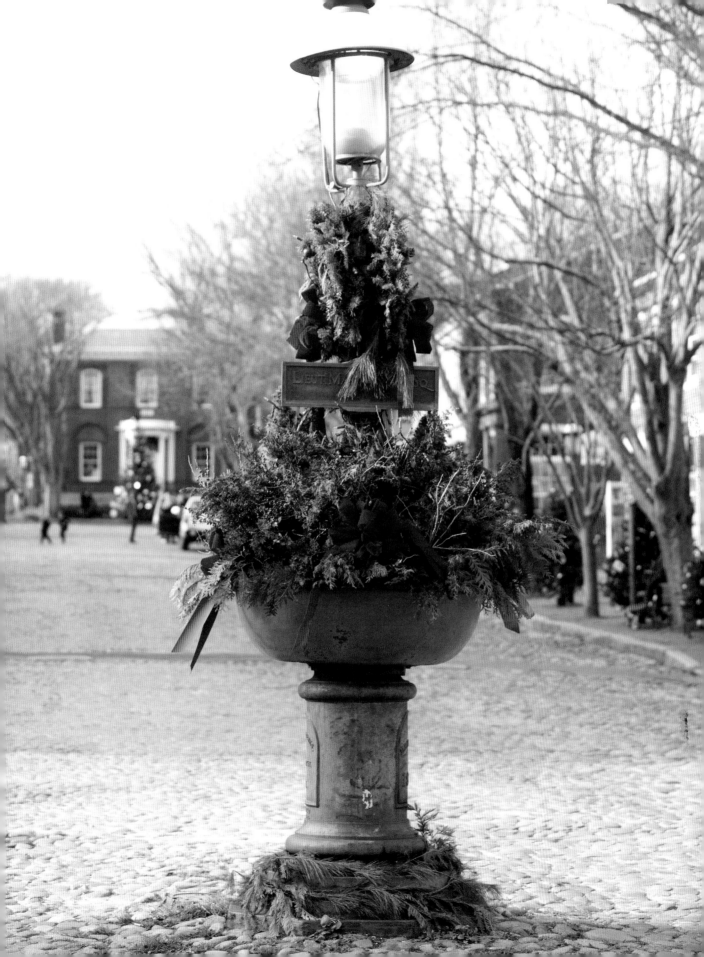

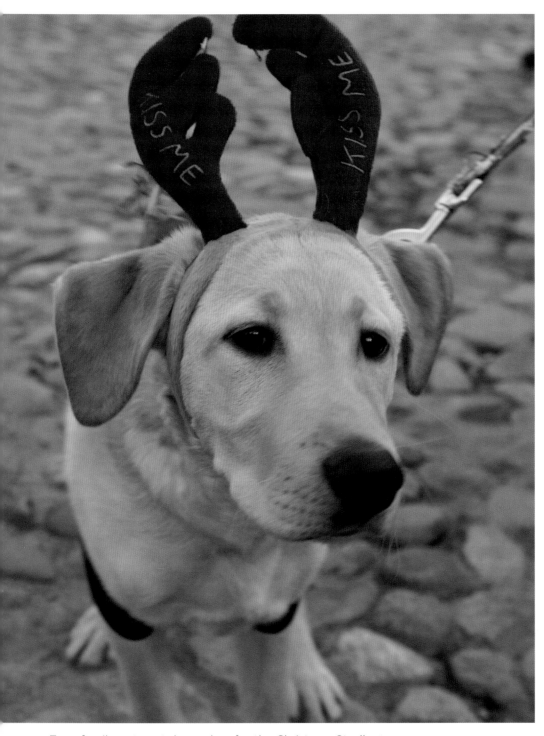

Even family pets get dressed up for the Christmas Stroll.

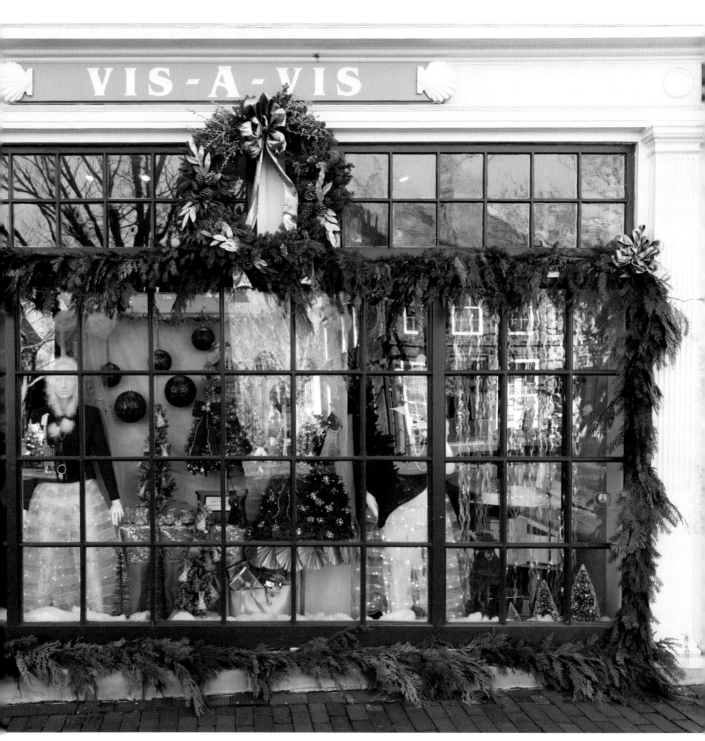

Vis A Vis, a clothing store on Main Street is decorated for the holidays.

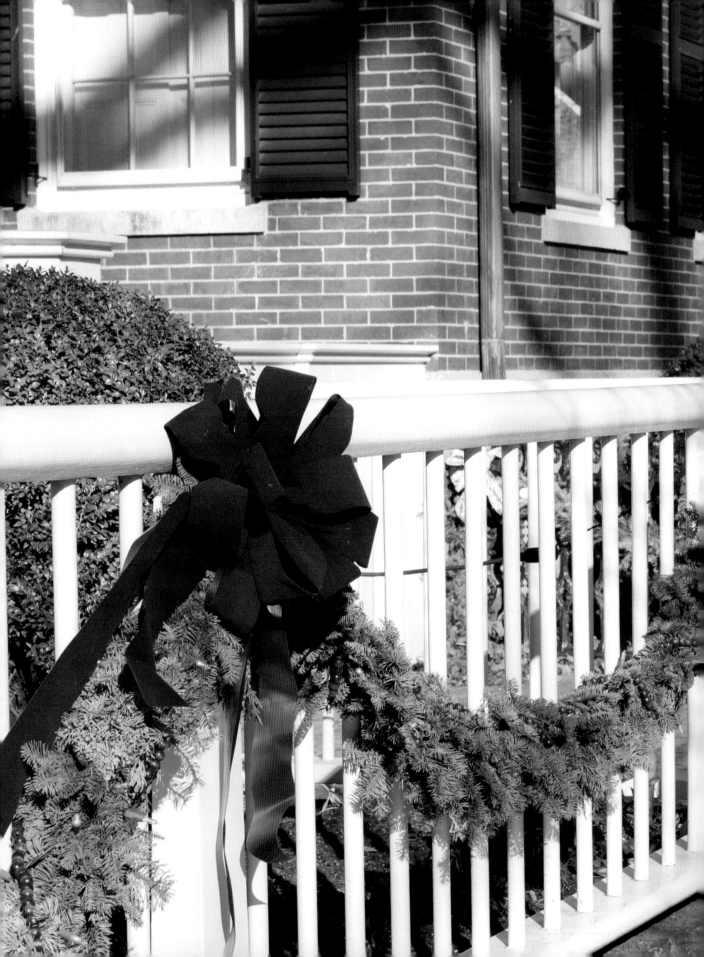

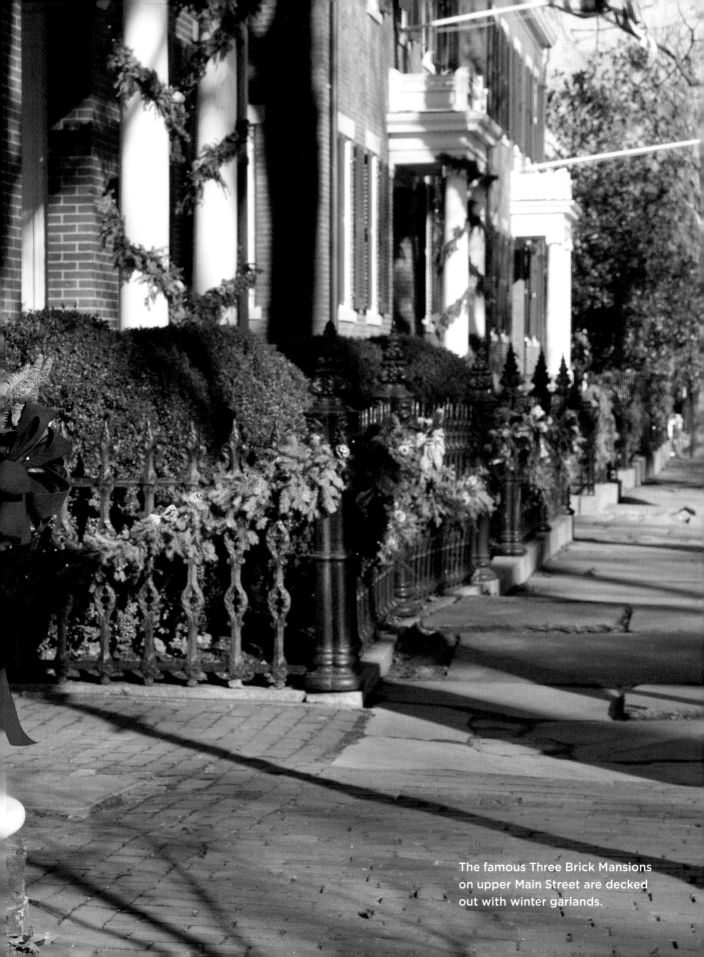

The famous Three Brick Mansions on upper Main Street are decked out with winter garlands.

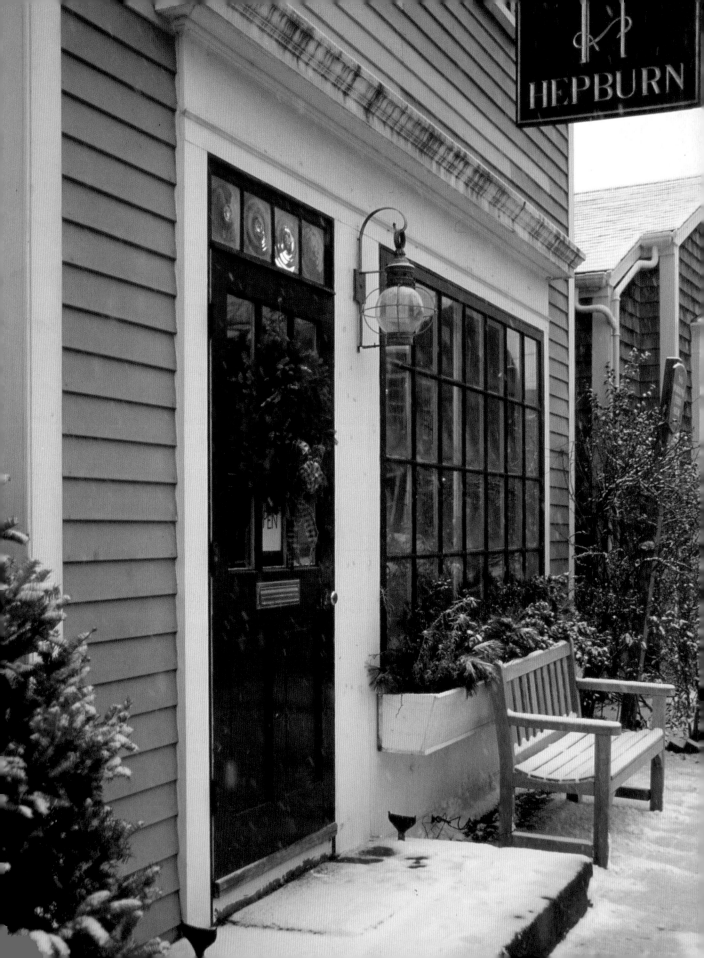

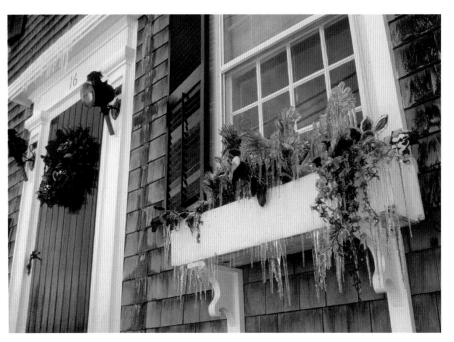

CLOCKWISE, FROM LEFT: Hepburn is a sophisticated women's clothing boutique, housed in a quaint old building on an in-town side street.

Even a frozen windowbox is beautiful.

Union Street is one of the oldest and prettiest streets in the historic district of Nantucket. One-way into town, this street is lined with cars during July and August, but on a snowy day in winter there's plenty of parking.

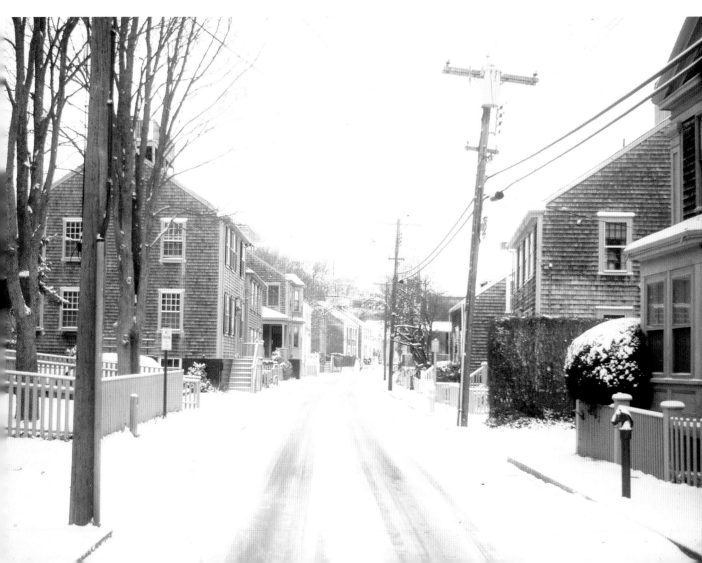

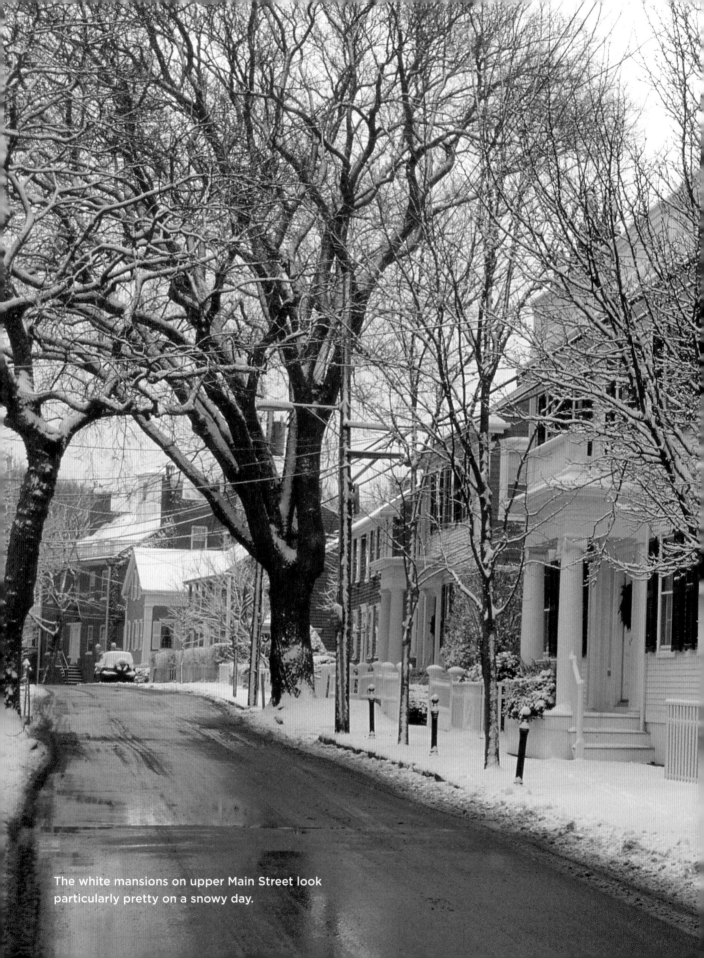

The white mansions on upper Main Street look particularly pretty on a snowy day.

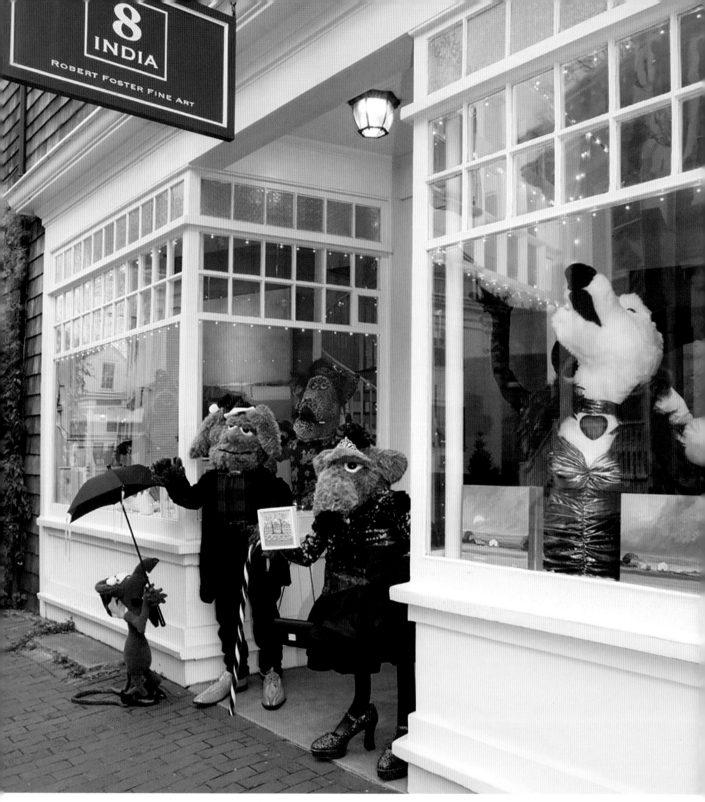

The Robert Foster Fine Art Gallery on India Street features the work of outstanding well-established local artists. For a special holiday event, artist Clara Urbahn created a group of whimsical, life-size critters that attended a fanciful art opening, each with a unique personality. The holiday party theme was designed and executed by interior designer David Holland and gallery owner Robert Foster.

The Jared Coffin House

This popular inn, in the center of town just a short distance from the steamship terminal, was originally built in 1845 as a private residence by Jared Coffin, a prominent shipowner. When it was refitted as a hotel in 1887 it was called the Ocean House and the basement was converted into a billiard saloon. In 1961 the property was purchased by the Nantucket Historic Trust and completely restored as the Jared Coffin House, a year-round hotel. Philip and Margaret Read purchased the inn in 1976 and the basement became the Tap Room,

a popular after-work gathering place favored by locals and vacationers alike.

Having been closed for many years by the current owners, Nantucket Island Resorts, the Tap Room has been restored and is once again open for business. Nantucketers welcome its return.

From Thanksgiving to New Year's Day the inn is decked out in all its holiday finery. The stone steps lead up to a massive front door that is traditionally decorated with a handmade cranberry wreath, commemorating Nantucket's harvest.

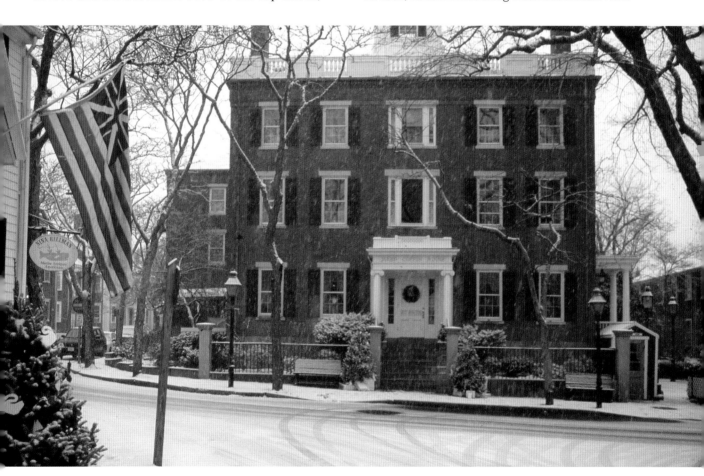

Built in 1845, the imposing Jared Coffin House Inn at 29 Broad Street is the oldest continuously operating inn on Nantucket. At Christmastime the inn provides a lovely traditional setting for guests who want a romantic holiday experience.

The Jethro Coffin House on Sunset Hill was built in 1686 and is believed to be the oldest on the island. It is one of the buildings now owned and maintained by the Nantucket Historical Association. It is open to the public and, with its period furnishings, offers a peek into what life in the seventeenth century might have been like.

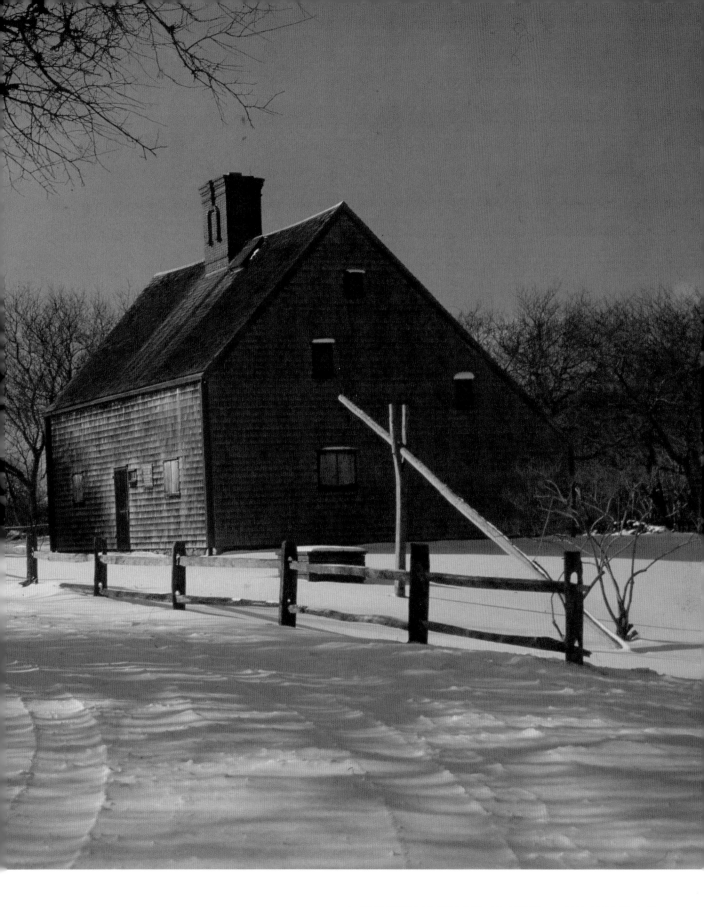

United Methodist Church

The Nantucket United Methodist Church, erected in 1823, stands at the corner of Main and Centre Streets. Extensive improvements were made in 1840 when the pulpit, originally in front of the church, was relocated to the rear, where it now stands, and the pews were turned to face it. A new gable roof was built on top of the old one, and an impressive portico with six Ionic pillars was added.

The simplicity and strength of the design reflect the sturdy character and reverence of the seafaring men who built the church. That quality is seen in the deep paneling of the balconies, the single-wide boards that form the pew backs, and the mahogany top rails that have no intricate carving but end in a graceful swirl. The paneled door leading to each pew, so quaintly reminiscent of another era, originally served the practical purpose of holding in the heat of the foot warmers provided by each pew holder. The pew holders also installed custom-built hymnal racks and armrests in their pews. In 1995 a non-profit organization composed of members of the church and community, formed the Two Centre Street Restoration Project for the purpose of restoring the building.

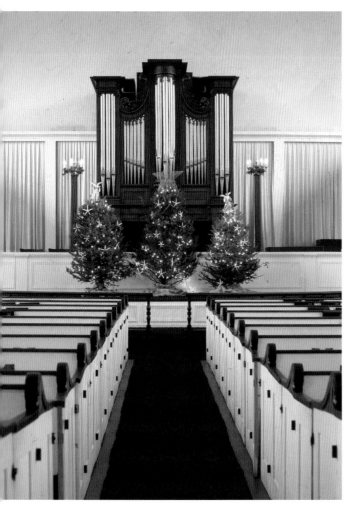

LEFT: United Methodist Church at Two Centre Street was built from 1822 to 1823. The ceiling is supported by sixty-foot-long, twelve-by-twelve-inch hand-hewn beams, brought to the island on whaling ships. The building is both a historic architectural gem and an active center for worship, community meetings, and the performing arts. In 1999 then First Lady Hillary Clinton visited this site and made the building part of the Save America's Treasures Program, a joint effort of the National Trust for Historic Preservation and the White House. A rare Appleton pump organ, built in Boston in 1831, was installed in the 1850s; it is one of only five in existence. Local designer Donna Elle Interior executed the simple holiday decorations in keeping with the building's architectural style.

RIGHT: To continue the simple theme, an evergreen wreath is decorated with a single starfish ornament and hung in each of the massive floor-to-ceiling windows of the church.

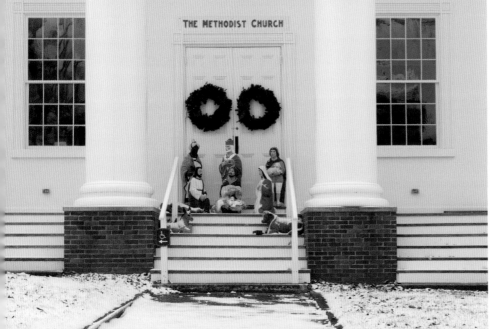

LEFT TOP: Strands of clear light and starfish ornaments cover the live trees at the front of the United Methodist Church.

LEFT BOTTOM: A manger scene on the steps of the United Methodist Church

FACING PAGE: Designed by architect Frederick Brown Coleman, the Nantucket Athenaeum Library on the corner of India and Federal Streets was completed after the original building was completely destroyed in the Great Fire of 1846. Many great luminaries lectured here, including Ralph Waldo Emerson, Henry David Thoreau, Horace Greeley, Lucretia Mott, Frederick Douglass, and Maria Mitchell. The 1996 renovation and restoration reopened the second floor Great Hall for lectures and research, provided gallery and conference space on the lower level, and created the Weezie Library for Children. The library currently maintains a forty-thousand-volume collection. A simple wreath adorns the front door, and when it snows, the happy sound of children having a snowball fight can be heard in the library park adjacent to the building.

THE METHODIST CHURCH

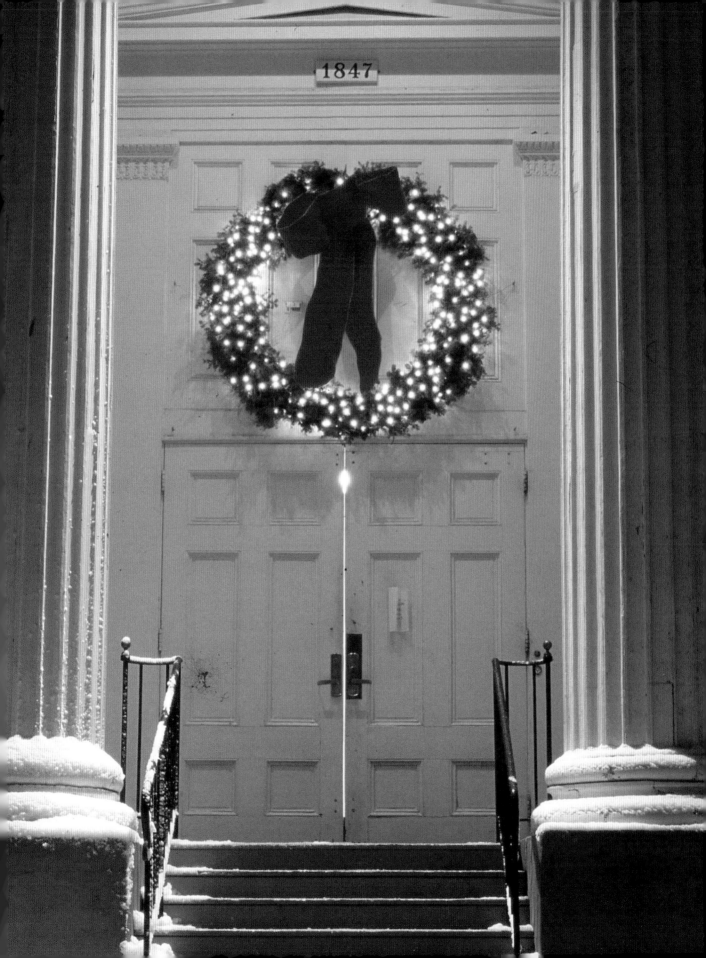

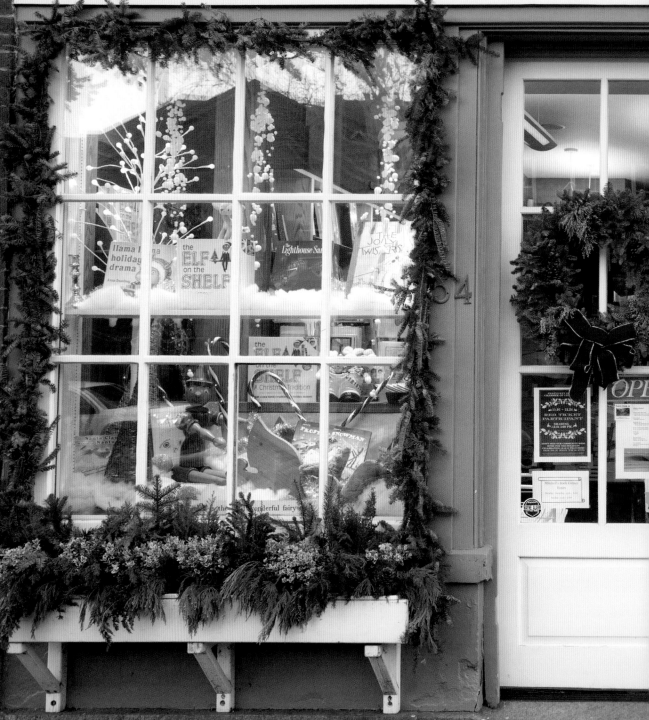

Mitchell's Book Corner on Main and Orange Streets has been an independent bookstore serving the community's literary needs since 1968 and offering the most extensive selection of books available about Nantucket. Their charming two-floor space is a regular meeting place for islanders and visitors year-round.

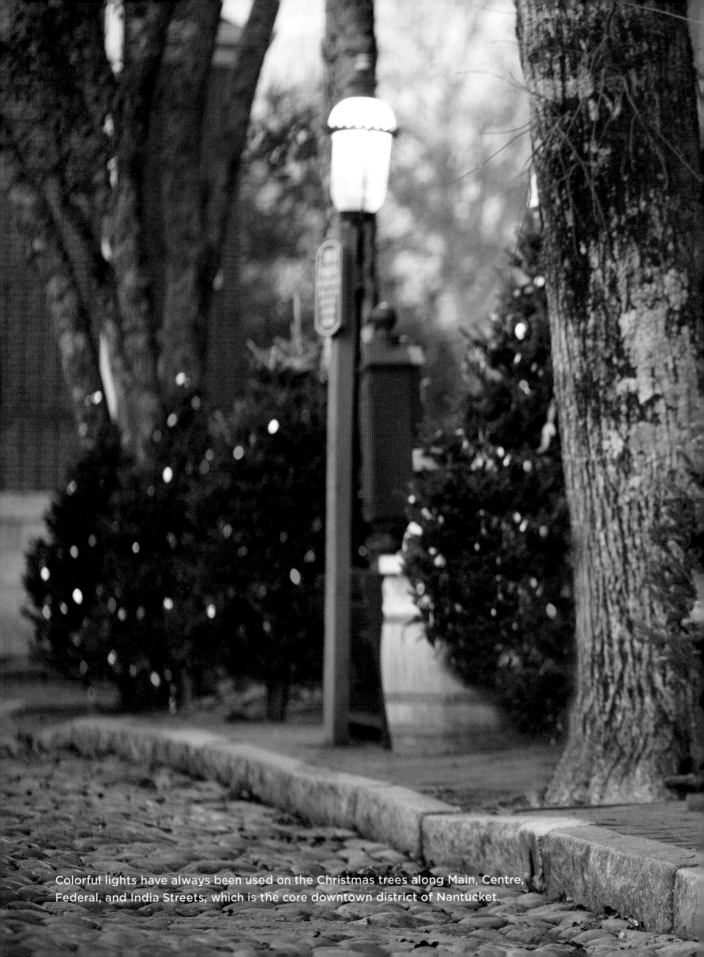

Colorful lights have always been used on the Christmas trees along Main, Centre, Federal, and India Streets, which is the core downtown district of Nantucket.

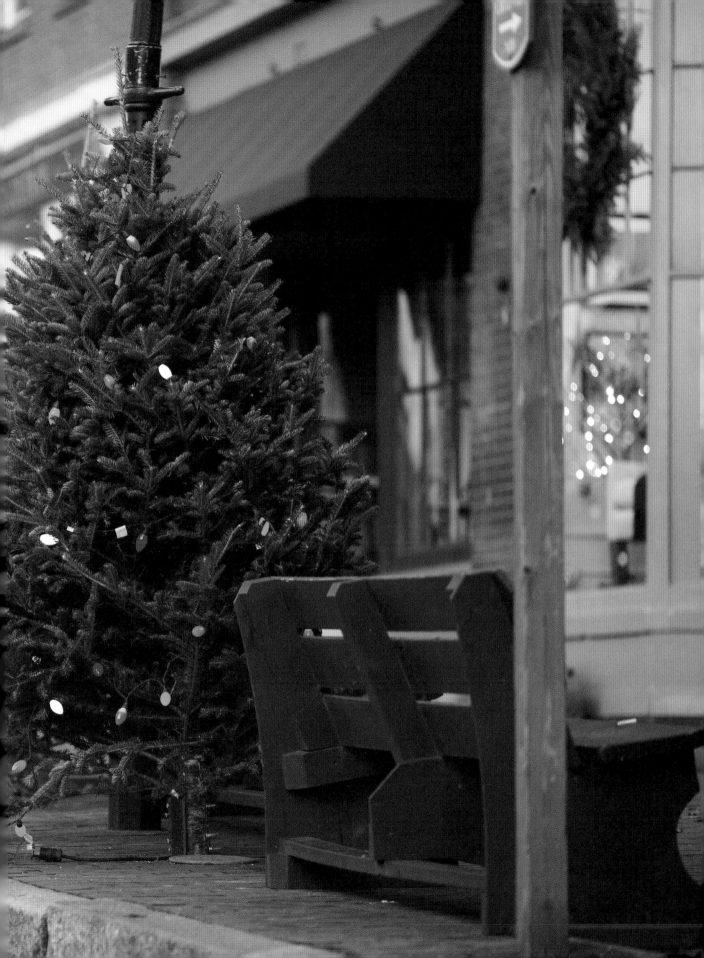

The Old Mill on Mill Hill was built in 1746 and is still in use, grinding corn as it did more than 270 years ago.

ARAISO 5,335 MILES
MELBOURNE 11,253 MILES
DAYTONA BEACH 1,282 MILES
BUENOS AYRES 6,914 MILES
'SCONSET 7½ MILES
BERMUDA 690 MI. WAUWINET 9 MI.
CAPETOWN 11,033 MILES
LONDON 3,612 MILES
PARIS 3,746 MILES
MOSCOW 5,335 MILES
CALCUTTA 11,124 MI

A popular place to take selfies is in front of the compass painted on the side of the Ralph Lauren building on the corner of Main and Washington Streets.

The Festival of Trees

The Nantucket Historical Association is responsible for the upkeep and operation of many historic sites on the island, including two museums and a research library. Their collection represents many aspects of Nantucket's history, such as whaling, land and sea transportation, the Quaker religion, fine and decorative arts, farming, commerce, and architecture. The library contains more than forty five thousand photographs and thousands of books and manuscripts, including an outstanding collection of whaling ship logs.

One of the association's most popular fundraising events is the annual Festival of Trees, which takes place throughout the month of December. The Whaling Museum, featuring artifacts from Nantucket's time as a nineteenth-century whaling empire, including a full-size whale skeleton, is the site for this celebration. Fifty Christmas trees are brought in and local artists, designers, business owners, and community groups decorate each with a theme. A preview party is held the Thursday evening before Stroll weekend begins; members buy their tickets well in advance, as it is always a sold-out affair. Local restaurants donate their time and food, and it's a chance for islanders, visitors, and museum supporters to kick off the holiday season. The trees are then on exhibit for the entire month, and the museum is open to the public every weekend through Christmas.

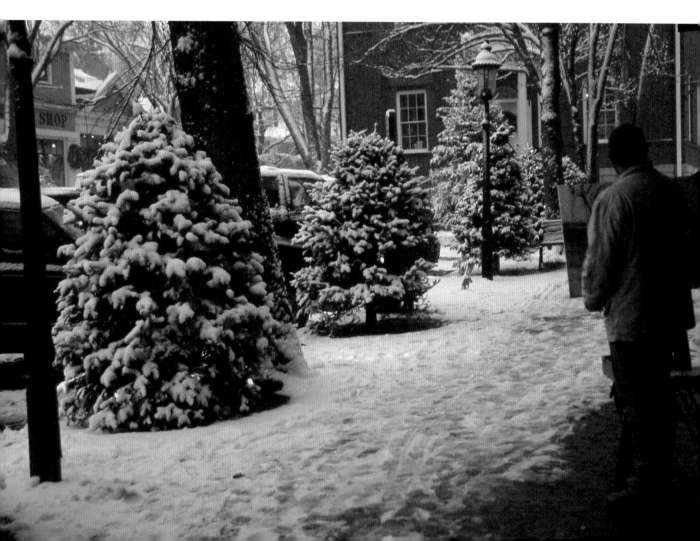

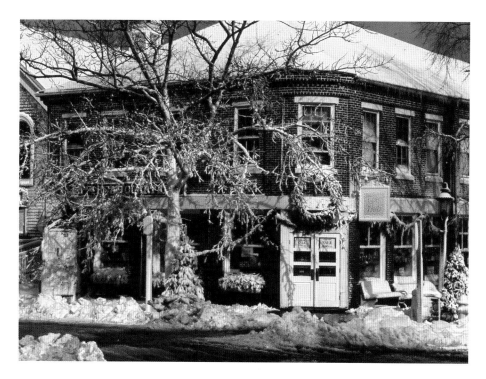

LEFT: The Hub at the corner of Main and Federal Streets

BELOW: Centre Street wears a coating of snow on a wintry day.

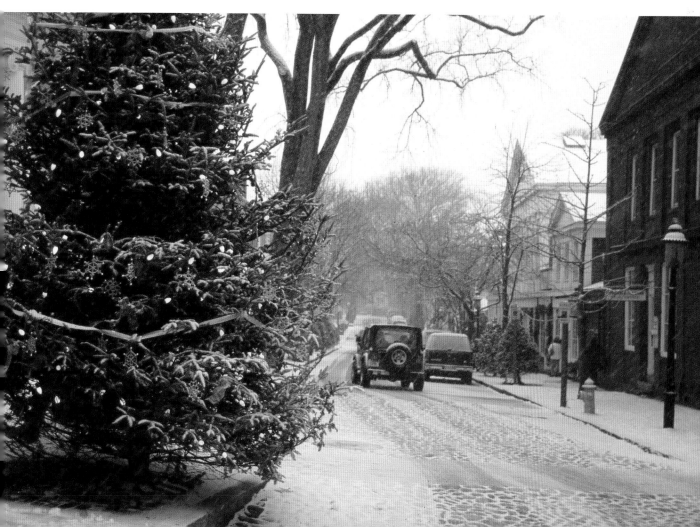

YOUR OWN CHRISTMAS TREE

Selecting a Tree

The following are some tips for selecting a tree.

- Spruce trees have sharp needles. They are great for holding large, heavy ornaments.
- Balsam and Fraser firs are very fragrant and hold needles for a long time.
- Scotch and white pine cost the least and are the most popular. Although their branches are not strong enough to support heavy ornaments, they last a long time and smell good.

Lighting the Tree

In keeping with the simple Nantucket style of decorating, most Nantucketers cover their trees with miniature clear lights. Lots of lights make a tree sparkle. To figure out the minimum number of lights needed, multiply the diameter of the tree (in feet) by eight, then multiply that number by the height of the tree (also in feet). If, for example, your tree is four feet in diameter and five feet tall, you would multiply four by eight, then thirty-two by five, for a total of 160 lights.

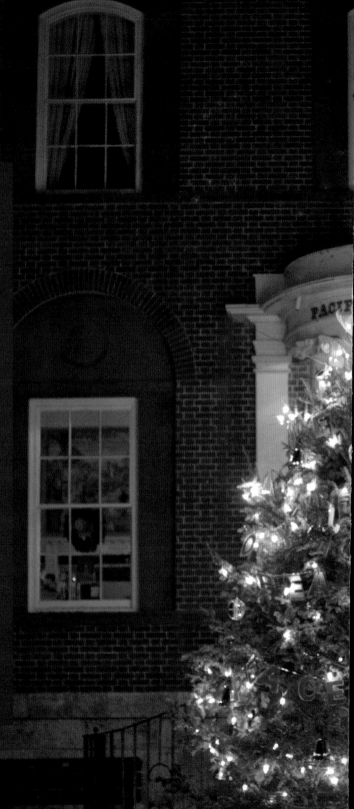

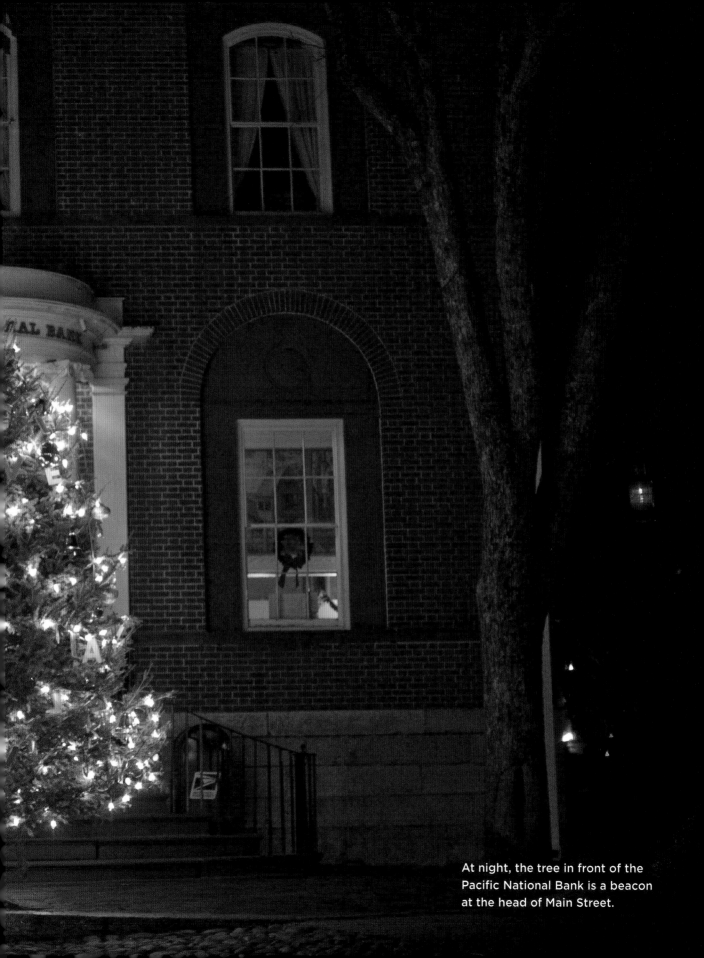

At night, the tree in front of the Pacific National Bank is a beacon at the head of Main Street.

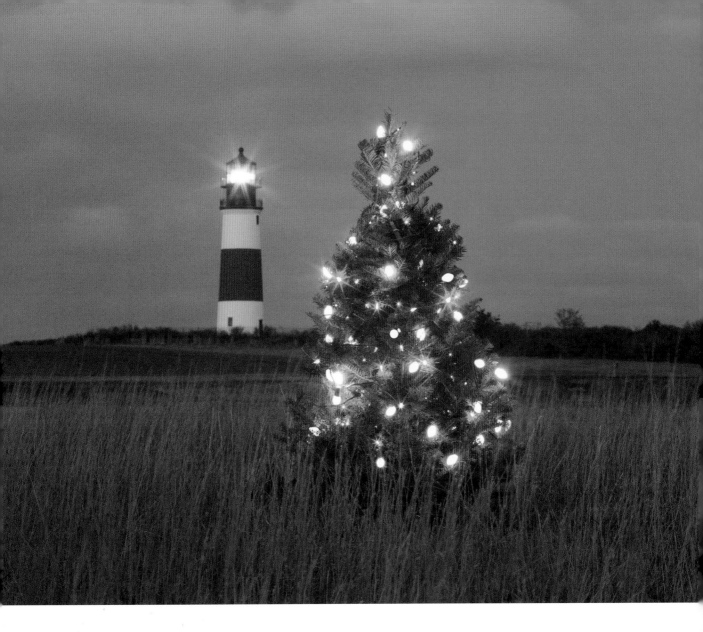

ABOVE: A tree is decorated in a lone, open area by the 'Sconset Lighthouse in the village, mostly inhabited in the summer months, but worth the seven-mile trip on Nantucket's only "highway," to see along with the early whale cottages.

RIGHT: Built in 1818, the imposing Federal-style brick structure of the Pacific National Bank, with its raised granite foundation and curved front steps, looms at the head of Main Street. In 1914 a music teacher in the Nantucket school system led a group of carolers around town, stopping to sing in front of the bank; and on Christmas Eve 1915, the first community Christmas tree on Nantucket was set up in front of the bank to celebrate the festive season. To this day Nantucketers gather here for caroling at Christmas. On a snowy day schoolchildren create their own interpretations of a winter bank customer in the form of a snowman.

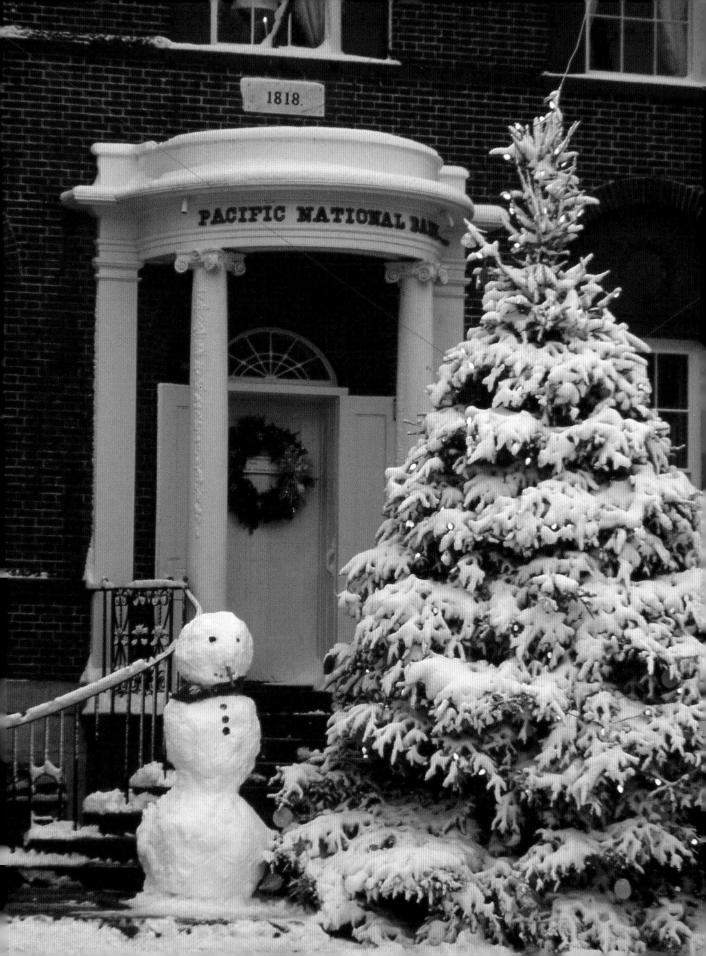

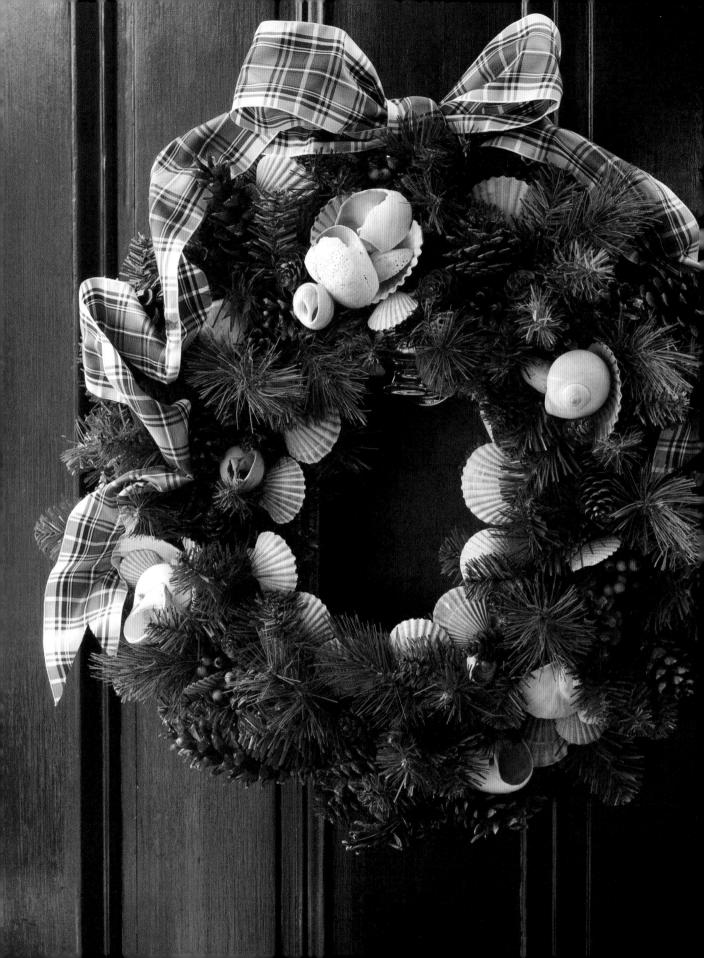

DECK THE DOORS

I n the nineteenth century, when Quakers dominated the island, there were hardly any changes during the month of December—no adornments of any sort on doorways, and certainly no wreaths. And even though newly settled Nantucketers indulge in lighted shrubbery here and there or string Christmas tree lights along picket fences, door decorations remain rather simple.

First Impressions

A decorated front door is the very first impression you make to welcome guests during the holidays. Many Nantucketers hang a simple wreath or pine branches on their doors even before Thanksgiving weekend. Since the houses in town are close together and close to the street, passersby can enjoy these holiday touches.

A festive mood is easy to create with anything from a few branches of greens tied with a bow to a wreath made of scallop or mussel shells. Perhaps the most celebrated house decoration in town is the cranberry wreath that hangs on the beautiful massive door of the Jared Coffin House Inn.

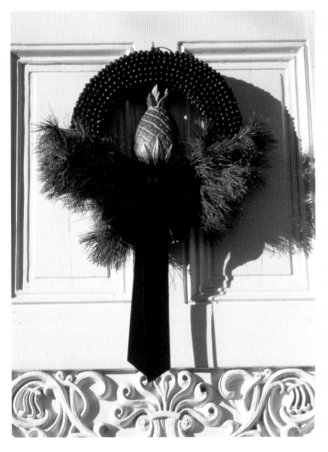 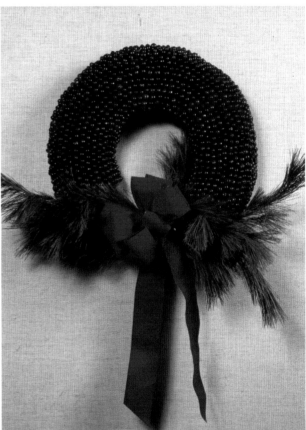

MAKING A CRANBERRY WREATH

Fresh, hard cranberries, straight pins, and a straw or foam wreath form are all that is needed to make a cranberry wreath. If the wreath is wrapped in plastic, there is no need to remove it. Simply secure the cranberries to it with a long pin stuck through the center of each berry. Arrange the cranberries in very tightly packed circles to cover the entire front of the form. The back of the form is left bare, as it will be placed against the front door. Hang with a loop of monofilament or fishing line.

LEFT: The pineapple design of the brass knocker on the front door of the Jared Coffin House Inn symbolizes welcome. The handmade cranberry wreath is symbolic of Nantucket's cranberry harvest.

MIDDLE: Another version of a cranberry wreath adorns a Nantucket doorway.

RIGHT: A red cranberry wreath hangs on the plain board door of an early island home. Window lights above the door are called transoms. The inside ledge often held "witches balls"—glass spheres said to keep evil spirits away.

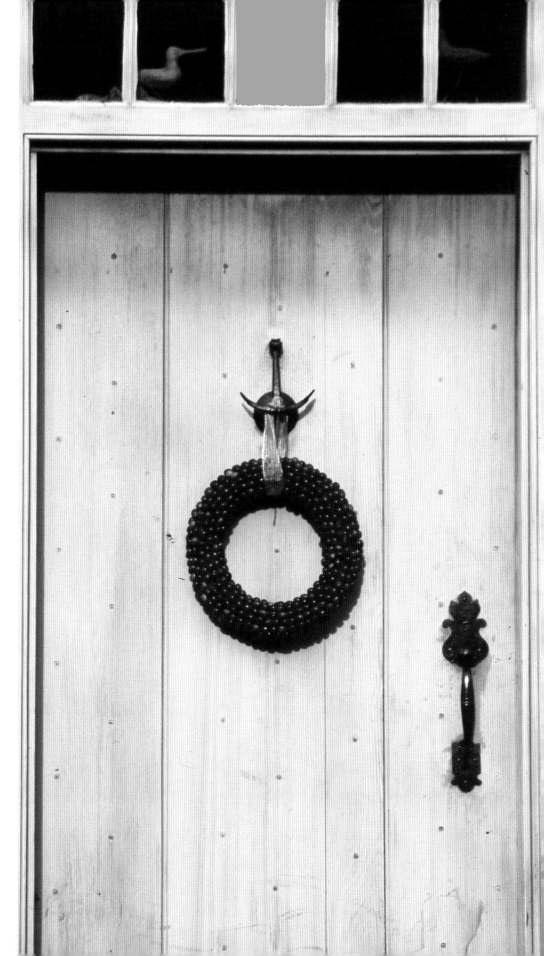

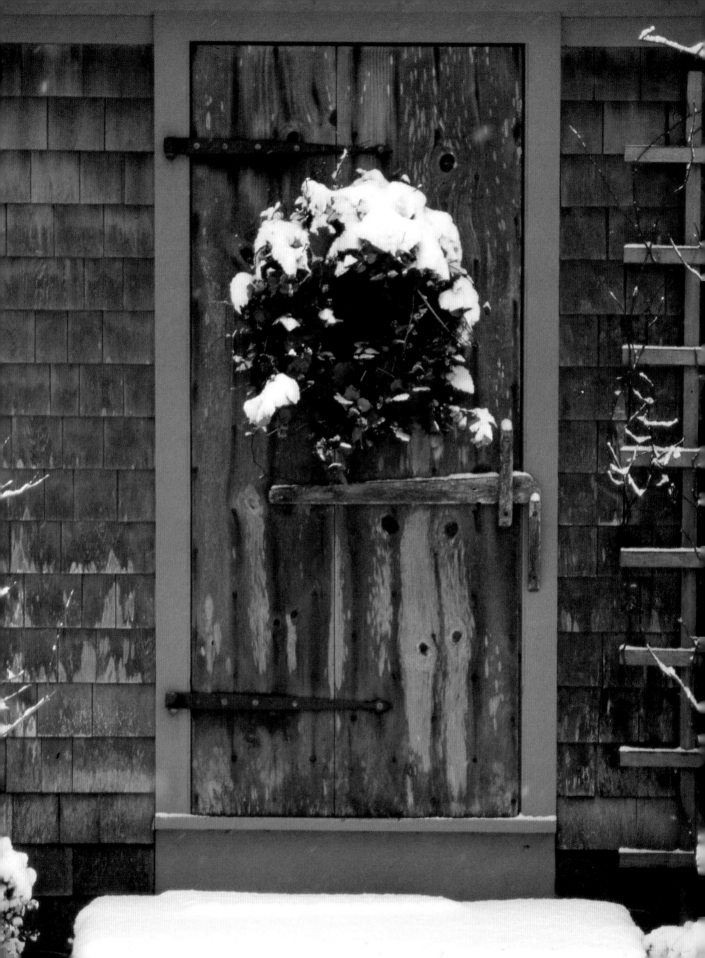

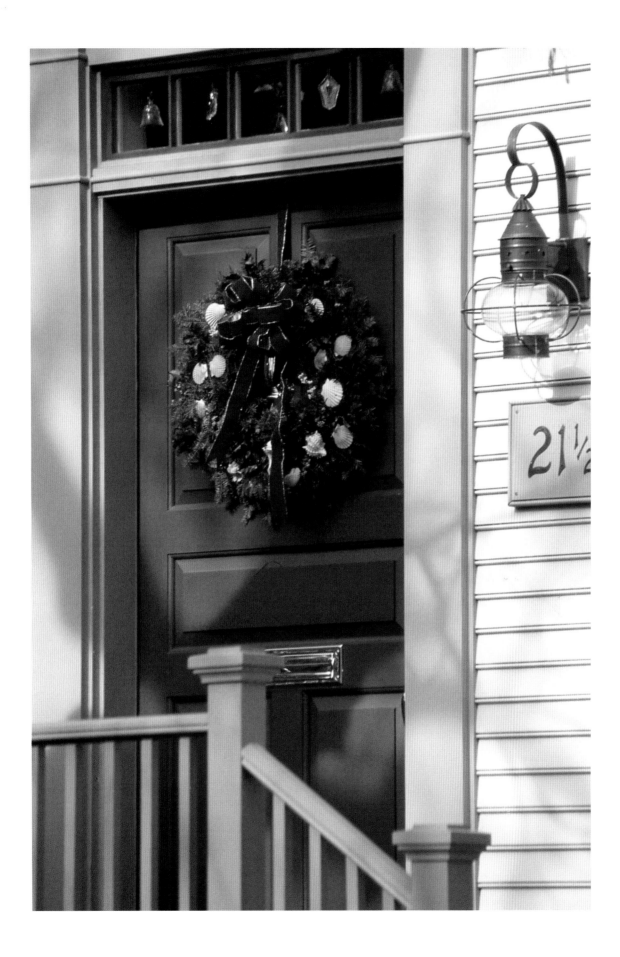

ABOVE: A simple sprig of greens held with a red ribbon adorns the door of The Christopher Starbuck House, one of the oldest houses on Nantucket. First built in 1690, this building was later relocated from its original site in Sherburne, Nantucket's first settlement, to its present site on upper Main Street at the corner of Gardner Road.

LEFT: This lovely simple wreath hangs on the door of an early Quaker home.

RIGHT: In keeping with the style of this 1740 house, a simple wreath of greens dotted with local berries adorns the front door.

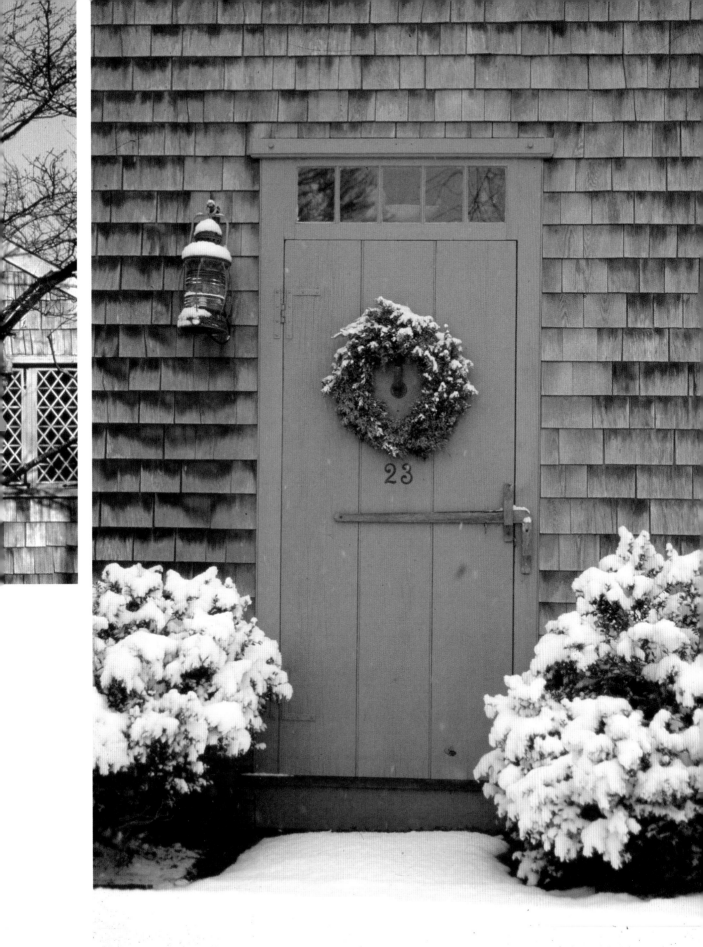

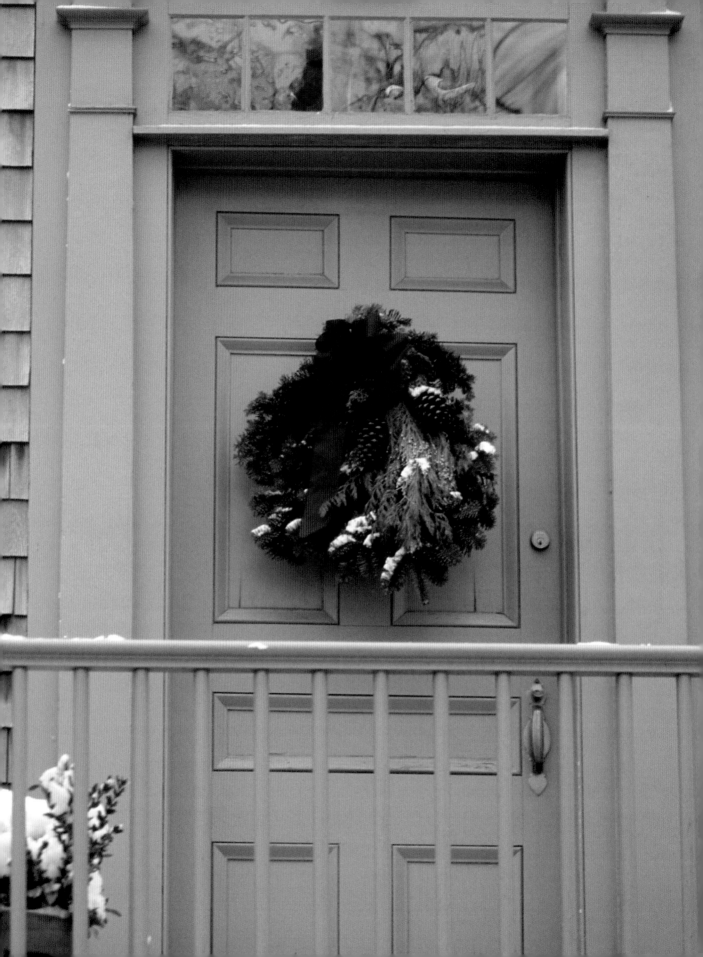

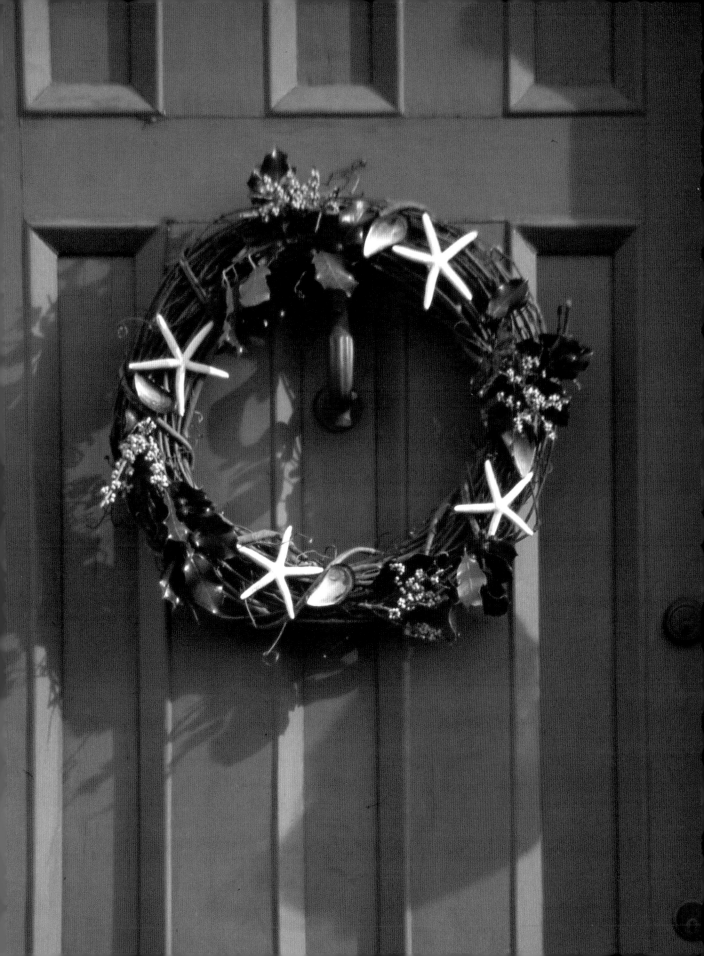

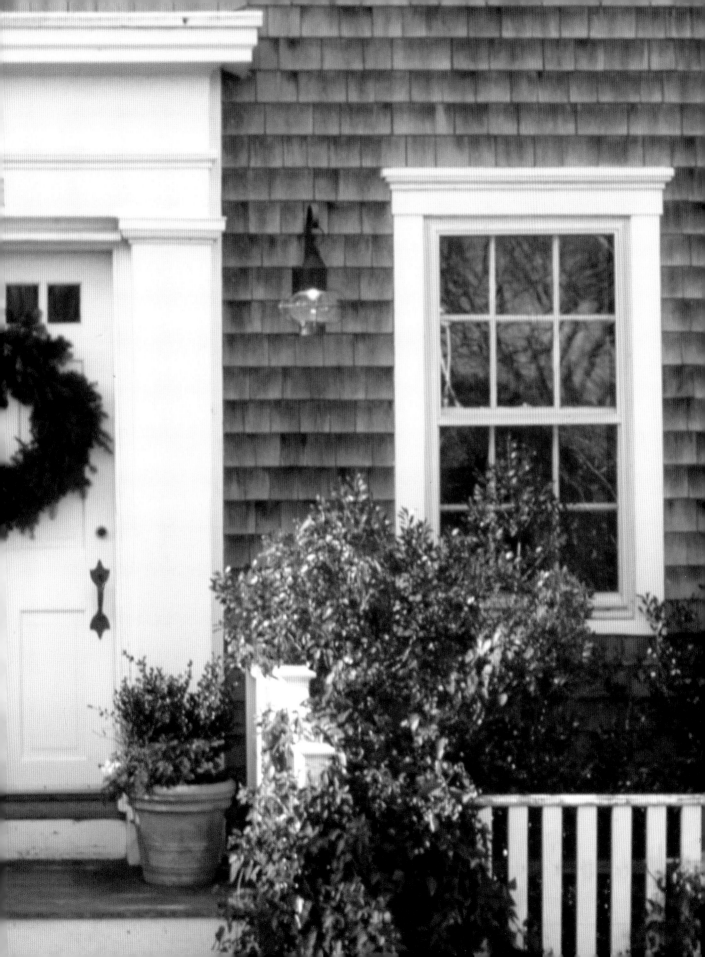

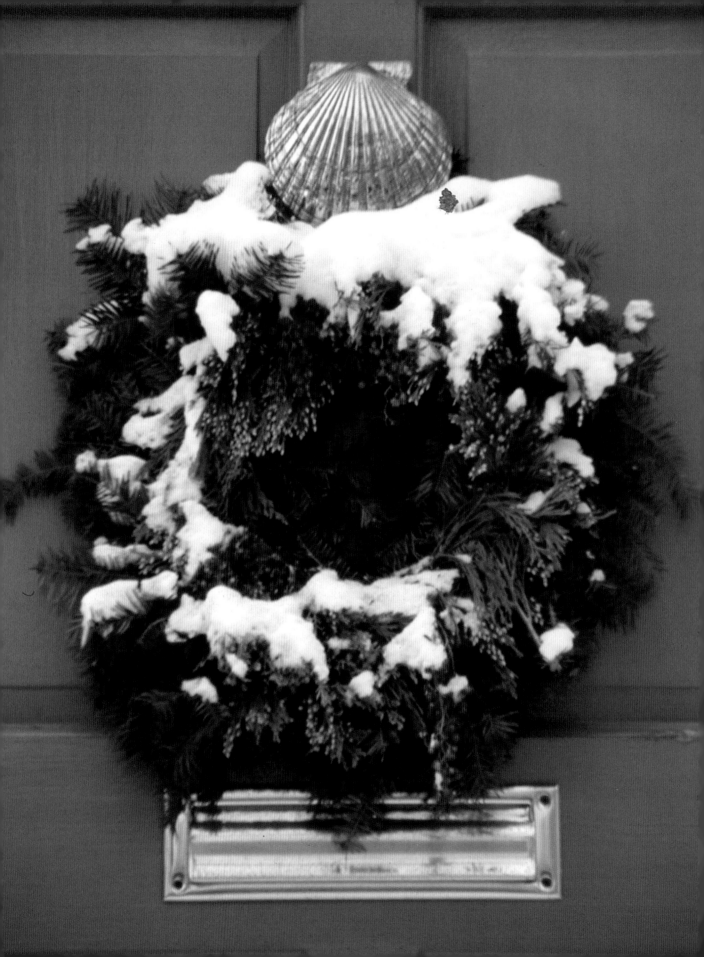

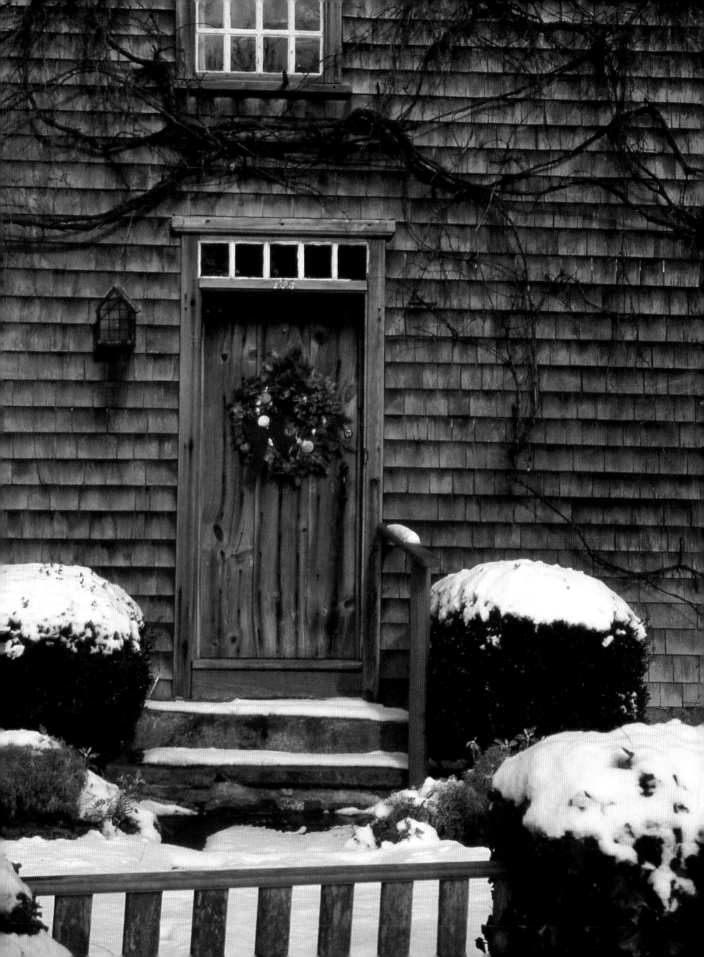

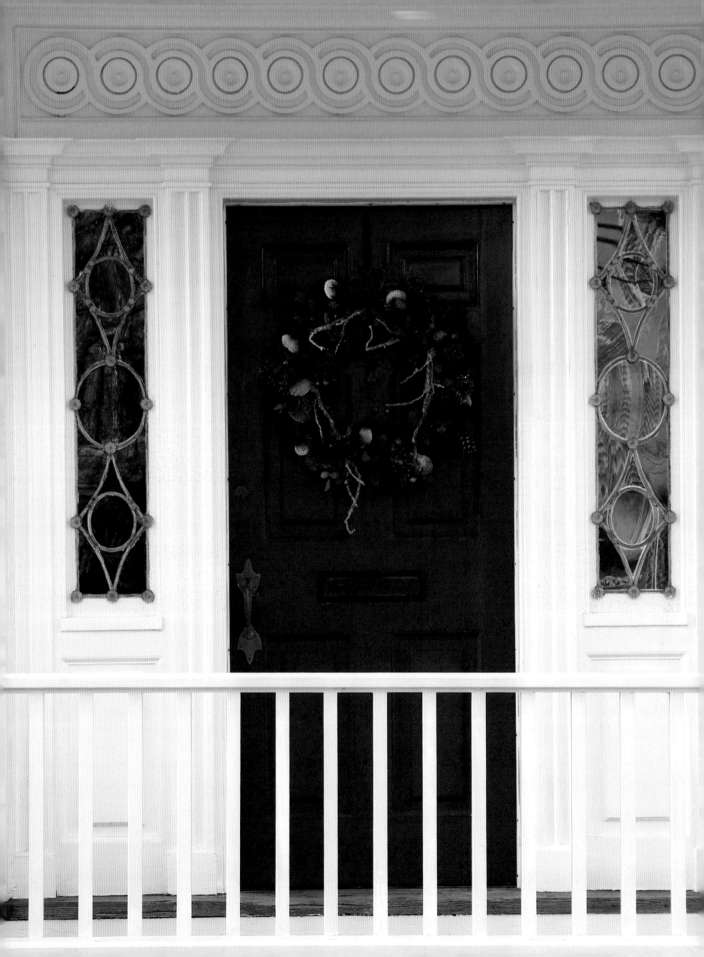

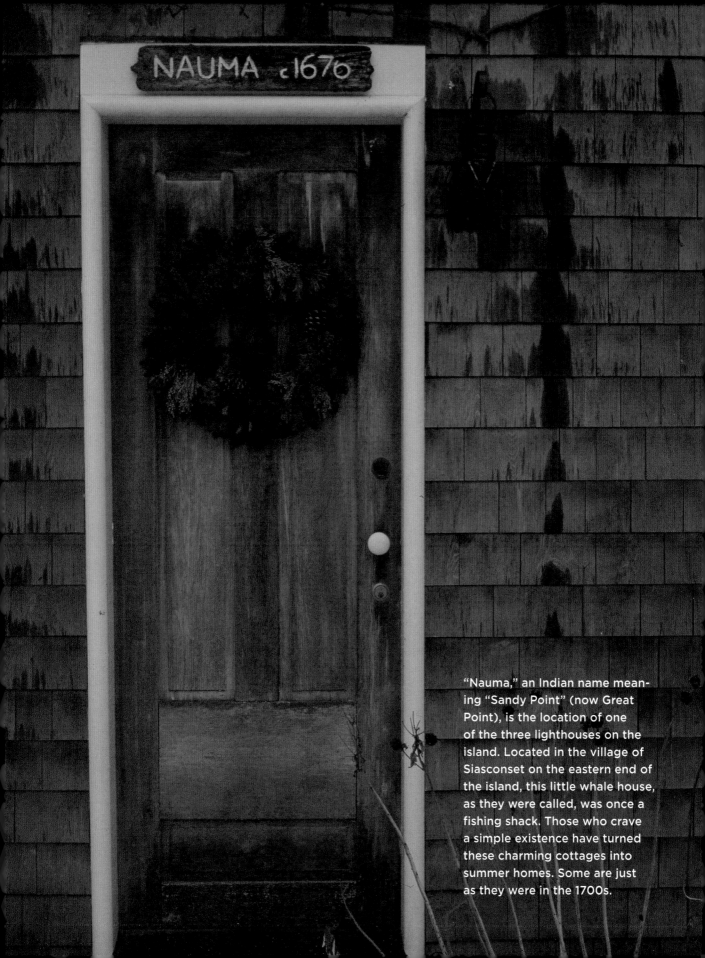

"Nauma," an Indian name meaning "Sandy Point" (now Great Point), is the location of one of the three lighthouses on the island. Located in the village of Siasconset on the eastern end of the island, this little whale house, as they were called, was once a fishing shack. Those who crave a simple existence have turned these charming cottages into summer homes. Some are just as they were in the 1700s.

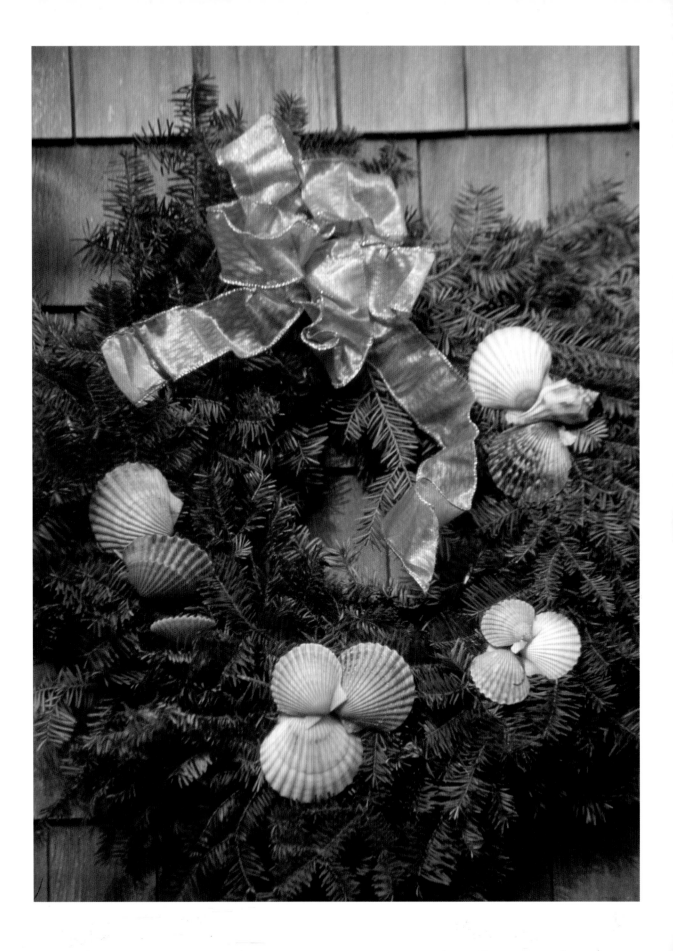

Matthew Starbuck

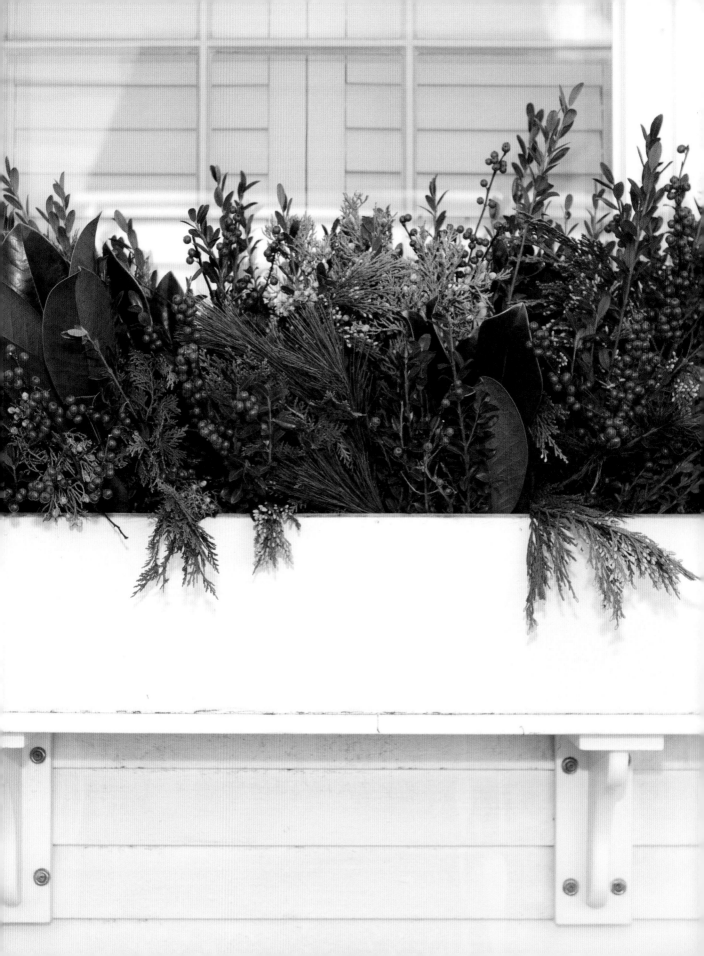

CHRISTMAS IN ISLAND HOMES

E arly island homes offer the perfect environment for tradi-
tional decorations. In keeping with Quaker influences, many
decorations are simple and reflect the style of the house. However,
the mansions on Main Street and the large former sea captains'
homes on Orange Street might be more lavishly decorated. During
the Christmas Stroll, a handful of beautiful island homes, within
walking distance of town and each other, are open to the public
for the Annual Holiday House Tour. These exquisite houses are
decorated by homeowners and island designers who volunteer
their creative talents. Some are quite lavish, others more modest,
but it is a wonderful opportunity to peek into these private interi-
ors and gain inspiration for your own decorations. All proceeds
go to charity.

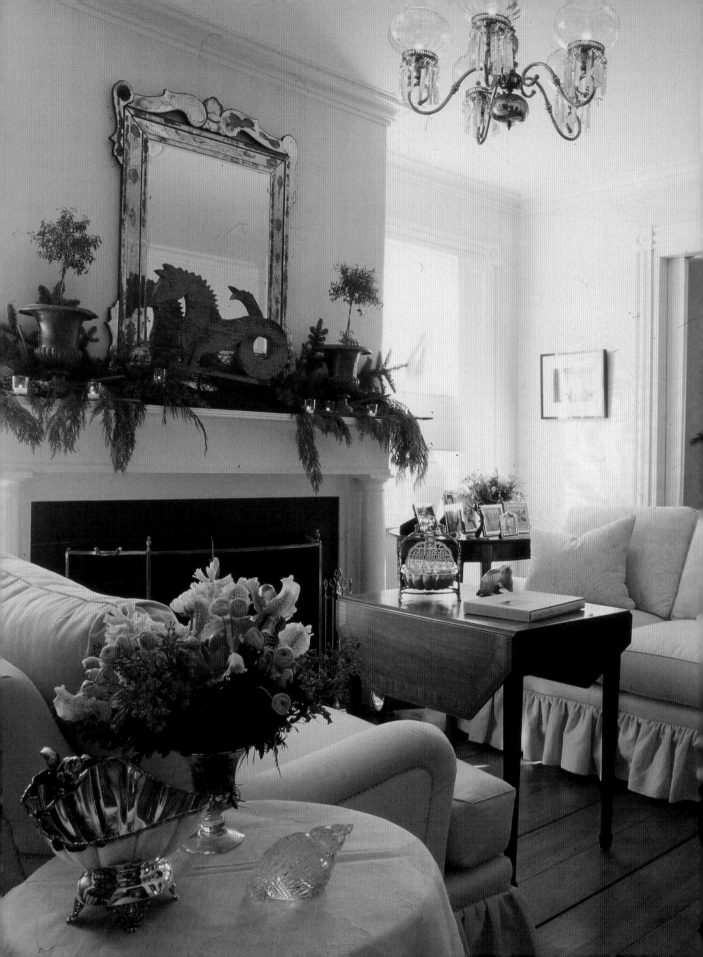

LEFT: This grand Federal-style mansion on Main Street is typical of those included in the Annual Holiday House Tour during the Christmas Stroll weekend. These houses have two rooms identical in size and style, one behind the other. Heavy pocket doors close between them and were originally used to conserve heat.

RIGHT: A center hallway in an early sea captain's home on Upper Main Street retains some of its original material, such as the wide pine floorboards found in humble, as well as grand mansions. These date back to the 1800s. The walls are faux finished to create what one would find in fashionable early-nineteenth-century interiors. The sideboard holds simple paper-white narcissus in a silver bowl, and a continuous strand of greens winds around the banister, extending the holiday decorations to the upstairs rooms.

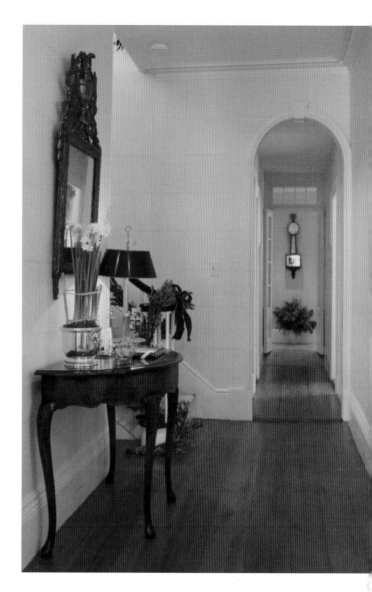

PAPER-WHITE NARCISSUS

Thought of as a holiday flower, paper-white narcissus have a wonderful strong fragrance and are easy to grow. The bulbs are available at garden shops and very inexpensive. They produce a lovely, delicate flower that brings freshness to any room. They blooms quickly and don't need soil. To start one, find a pretty container, approximately three inches deep or more, and fill it halfway with pebbles, shells, or gravel. I sometimes use sea glass in a clear glass container. Set the bulb on top and add water to cover half the bulb. Keep this water level by adding more as it evaporates. In about two weeks you will see blossoms; these bulbs will continue blooming for four to five weeks.

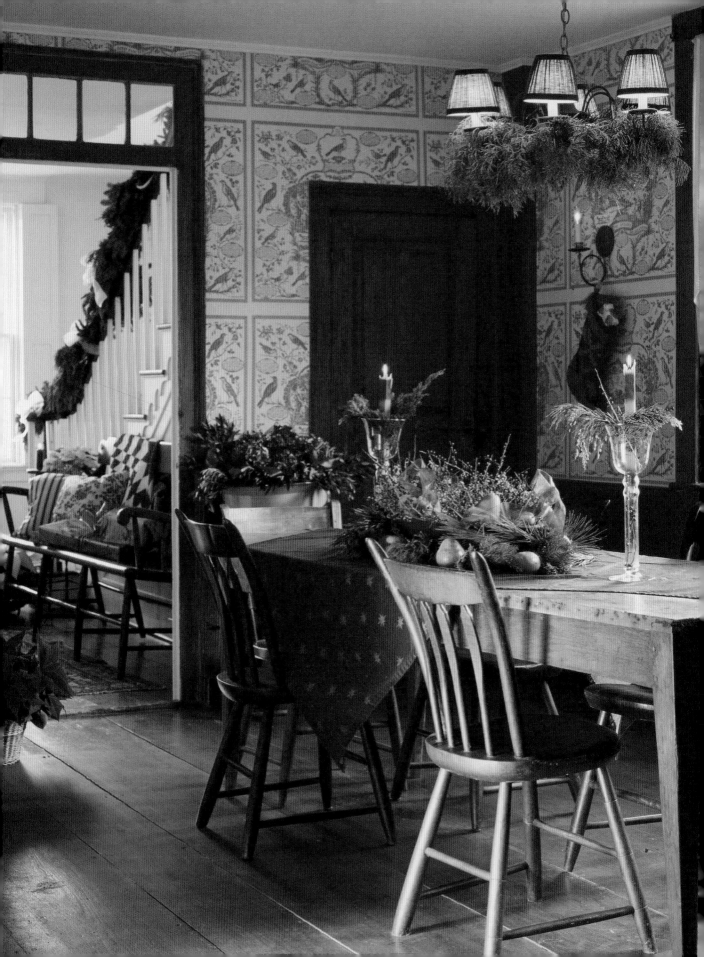

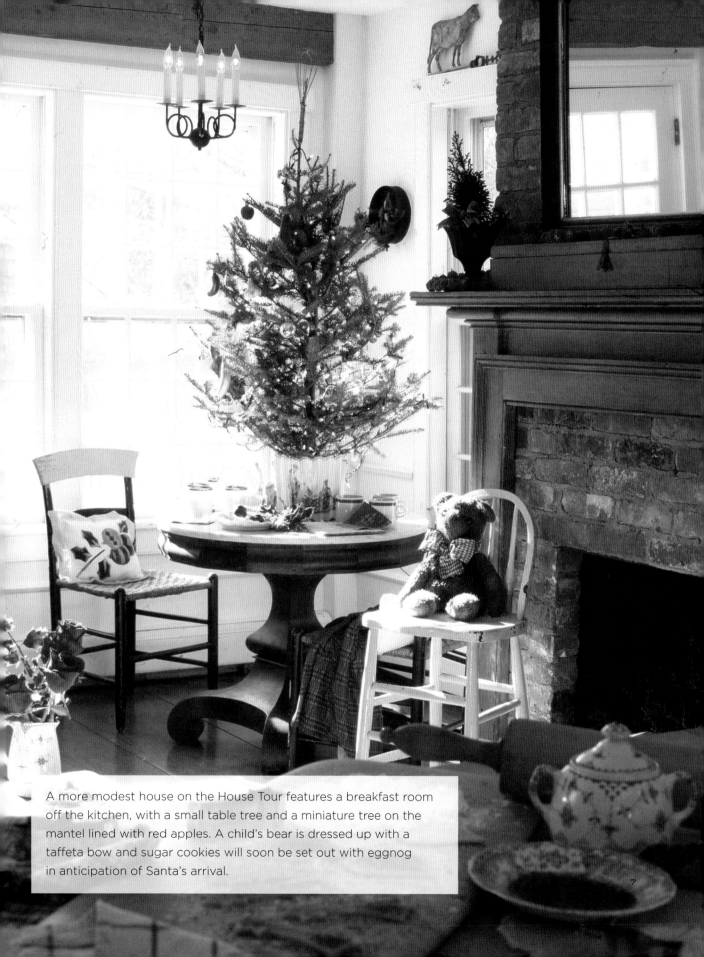

A more modest house on the House Tour features a breakfast room off the kitchen, with a small table tree and a miniature tree on the mantel lined with red apples. A child's bear is dressed up with a taffeta bow and sugar cookies will soon be set out with eggnog in anticipation of Santa's arrival.

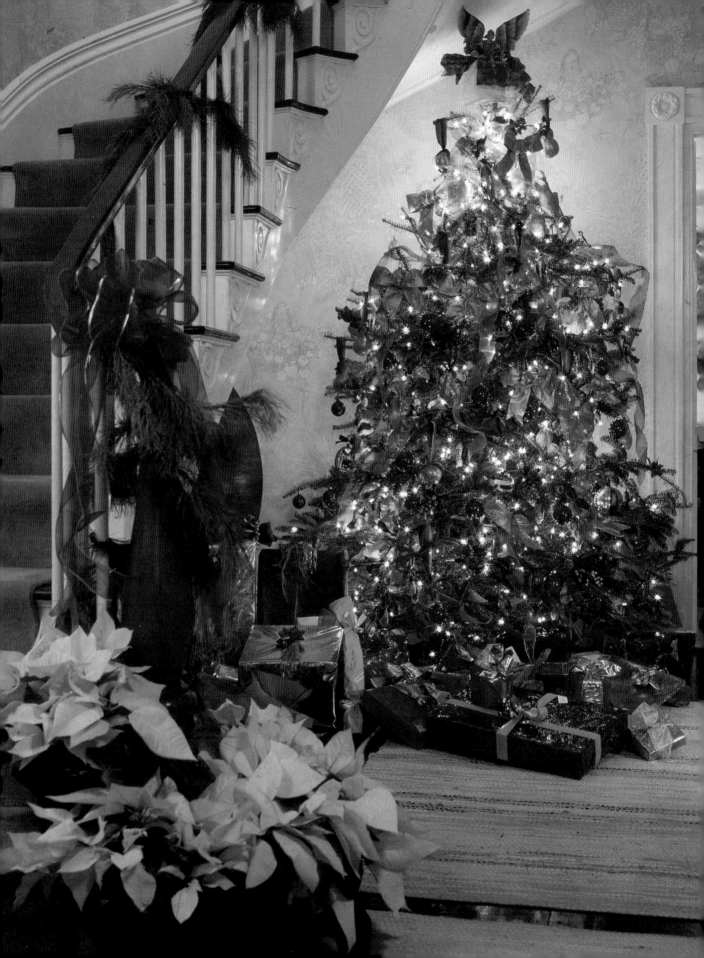

LEFT: A Greek Revival, early sea captain's home on Orange Street welcomes visitors with a ten-foot-tall tree lavishly decorated in the front entryway. A grouping of white poinsettia plants at the base of the staircase adds to the opulence of this entryway.

ABOVE: Guests are met with holiday cheer as soon as they open the front door of this house, where a collection of Nantucket-themed handcrafts is arranged on a table next to the tree.

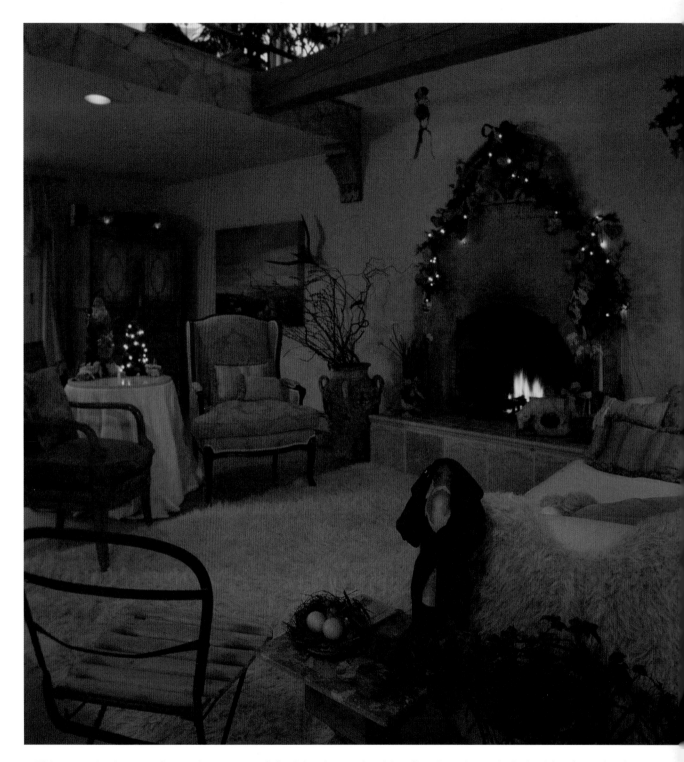

This untypical, newer home in an area of the island known as Fulling Mill off Polpis Road is where sheep were raised and shorn when farming was an industry here. The homeowner, an artist, built her home from repurposed salvage material. The beehive fireplace is encircled with a bough of greens holding needlepoint ornaments that relate to all the people and important landmarks in the artist's life. This creative style of building is not allowed in the historic district.

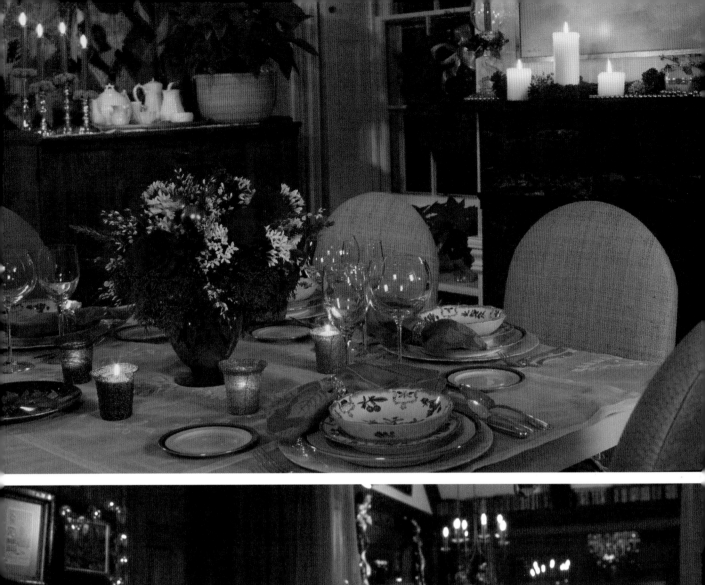

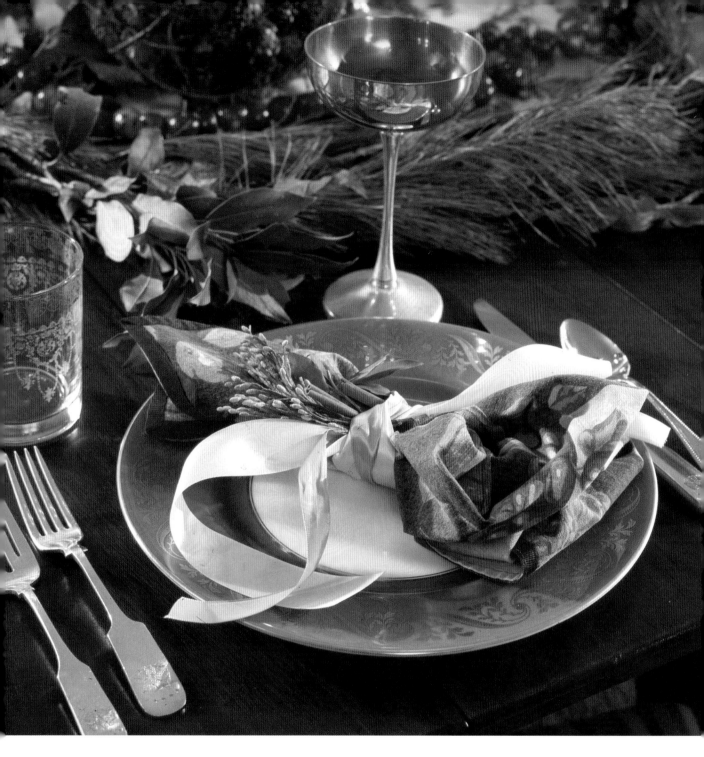

The casual breakfast room in this Main Street family home is playfully done in a Swedish country style, with a green apple and ivory color scheme. Painted kitchen chairs with country plaid cushions surround a scrubbed pine table. Miniature pine trees line the window ledge, and each sill is decked with greens and seashells collected on many summer beachcombing afternoons with small children in tow. Gingerbread men, fabric-wrapped balls, scallop shells, and strands of cranberries are scattered across the table set for a holiday breakfast.

SPECIALS

HOT RUM & CIDER

HOT MULLED WINE

CLAM CHOWDER

NANTUCKET BAY SCA

PERSONAL PLEASURES

I f you're dining out during stroll weekend you can't go wrong when picking a restaurant, but you want to be sure to make reservations. Many visitors to the island plan their trip around restaurant favorites and make reservations long in advance. The Company of the Cauldron on India Street is an intimate little restaurant housed in a delightfully charming old building in the middle of town. During the holiday season the restaurant is decorated with garlands of pine branches and pinecones over the front windows that face India Street. Cranberry garlands are always included in island decorations. The warm woods and simple décor create a convivial and relaxed atmosphere, making patrons feel as if they are in a friend's dining room. The menu, often consisting of four courses, is chosen by the chef and posted on the front of this tea-room-like façade so you can check it out before making your reservation.

A Whaling Bistro

The Brotherhood of Thieves familiarly short-ened by locals to simply "The Brotherhood," is a casual restaurant in a building built in 1847 and was once a whaler's hangout. In the summer-time, patrons wait in long lines to get into this popular dining room with its den-like atmo-sphere, long tables, and boardinghouse-style service. In the winter months, this is a local hangout, where a fire is always blazing and the atmosphere convivial.

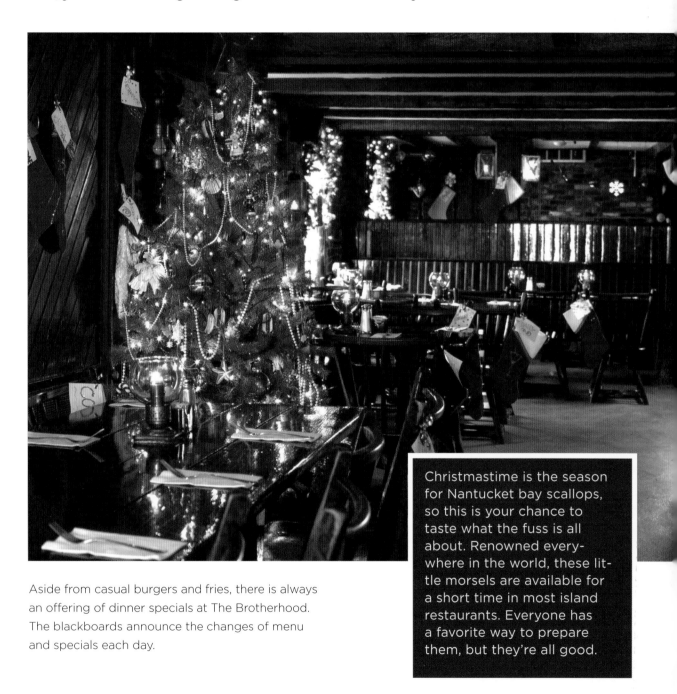

Aside from casual burgers and fries, there is always an offering of dinner specials at The Brotherhood. The blackboards announce the changes of menu and specials each day.

Christmastime is the season for Nantucket bay scallops, so this is your chance to taste what the fuss is all about. Renowned every-where in the world, these lit-tle morsels are available for a short time in most island restaurants. Everyone has a favorite way to prepare them, but they're all good.

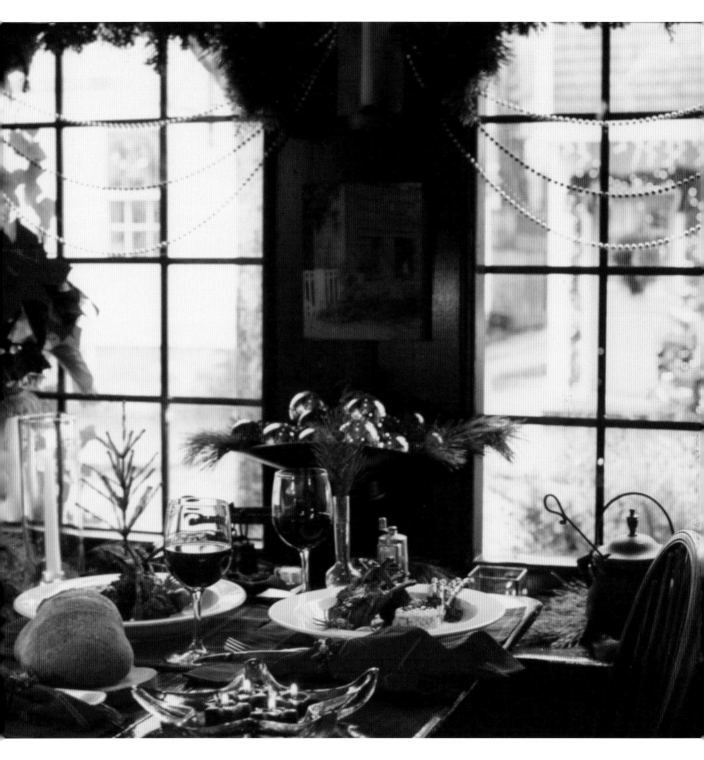

Company of the Cauldron is a romantic spot over-looking India Street and always offers a unique dining experience

Island Crafts

Lightship Baskets

Basket weaving is a time-honored craft originated by Native Americans and later taught to the first white settlers on Nantucket in the early 1600s. Like most crafts, basket weaving was born out of necessity; island Indians made and used baskets to store and transport food and other supplies.

However, the Nantucket lightship basket is different from any other basket you may have seen. These baskets, whether used as purses or to hold one egg, are considered valuable collectibles, not only on the island, but throughout the world.

These baskets are part of Nantucket's ongoing history related to the sea. Just as the craft of scrimshaw kept sailors busy during long stints at sea, making baskets did the same for lightship keepers. Collectors of island crafts get creative displaying these unique baskets as part of their Christmas arrangement.

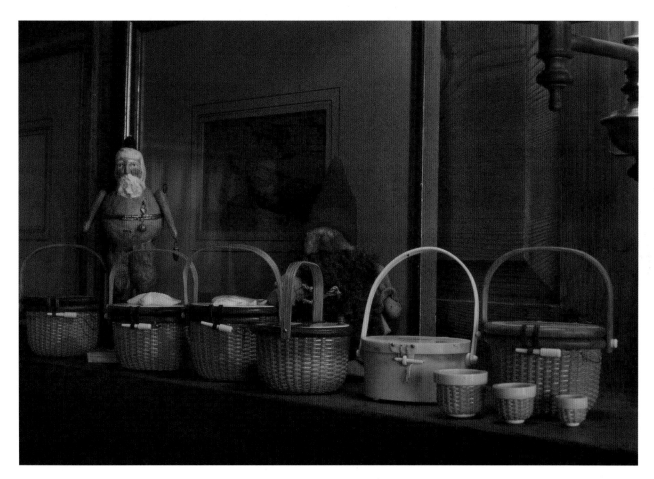

ABOVE: Early Nantucket lightship baskets are considered valuable collectibles.

RIGHT: A collection of scrimshaw and lightship baskets in varying sizes is arranged on a side table. White poinsettia plants go well with the color of the ivory scrimshaw whale tooth and ivory carvings on the basket.

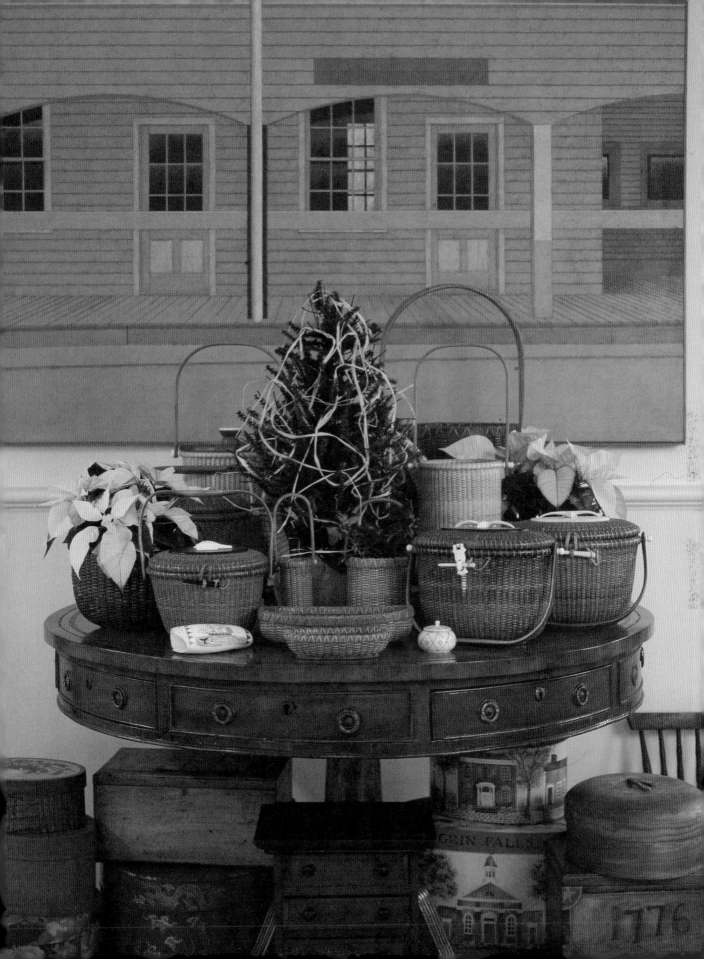

Scrimshaw

Scrimshaw is the art of scribing a design on a piece of ivory or bone. Scrimshaw, one of our first American folk crafts, originated during our nation's earliest years with New England whalers who spent several years at sea. To relieve boredom, sailors spent their leisure time drawing and scribing on whale teeth and bone. Some of the most popular early items were tool handles, clothespins, walking sticks, jagging wheels used in pie making, and busks to stiffen a woman's corset.

Because whaling is no longer done in this country, the availability of whale teeth is limited to what is left from the past, when supplies were imported from other countries. This is no longer legal and scrimshanders are turning to substitute materials such as bone and resin. As you would imagine there are not too many modern scrimshanders. However, if you'd like to see some fine pieces be sure to visit The Scrimshander on Centre Street, where Michael Vienneaux, a longtime craftsman in this art, can be seen plying his craft.

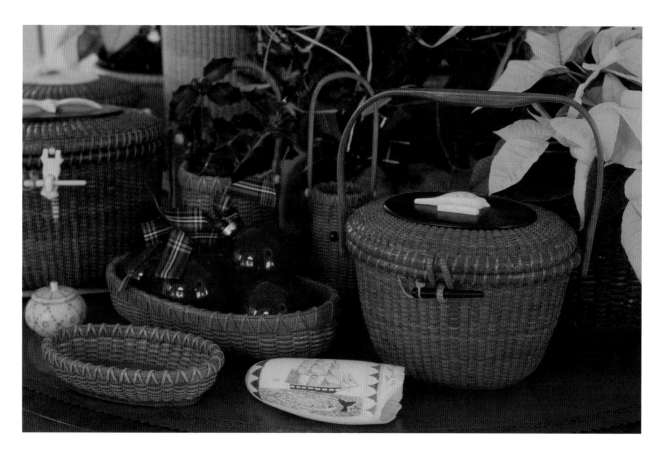

ABOVE: A fine collection of baskets and scrimshaw made by local artisans lines the mantelpiece of an early home. The scrimshaw is by David Lazarus, a respected longtime island artist and craftsman.

RIGHT: Green jaideite plates from the 1950s are used to set the table every Christmas. A green breadbox holds two miniature red chairs, and a wire basket is heaped with crabapples and sprigs of greens.

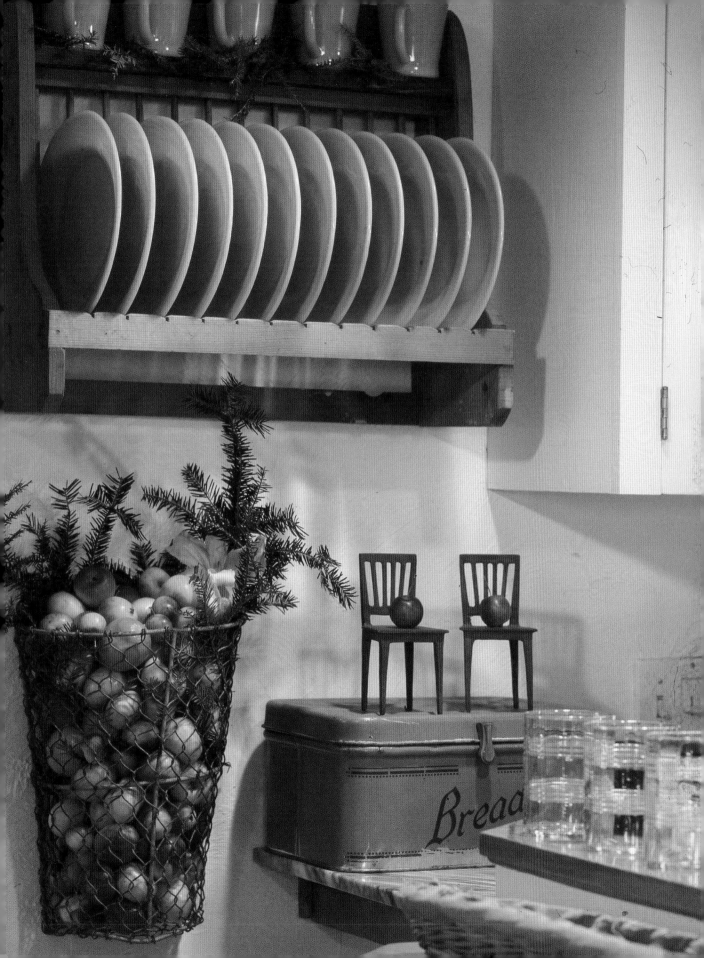

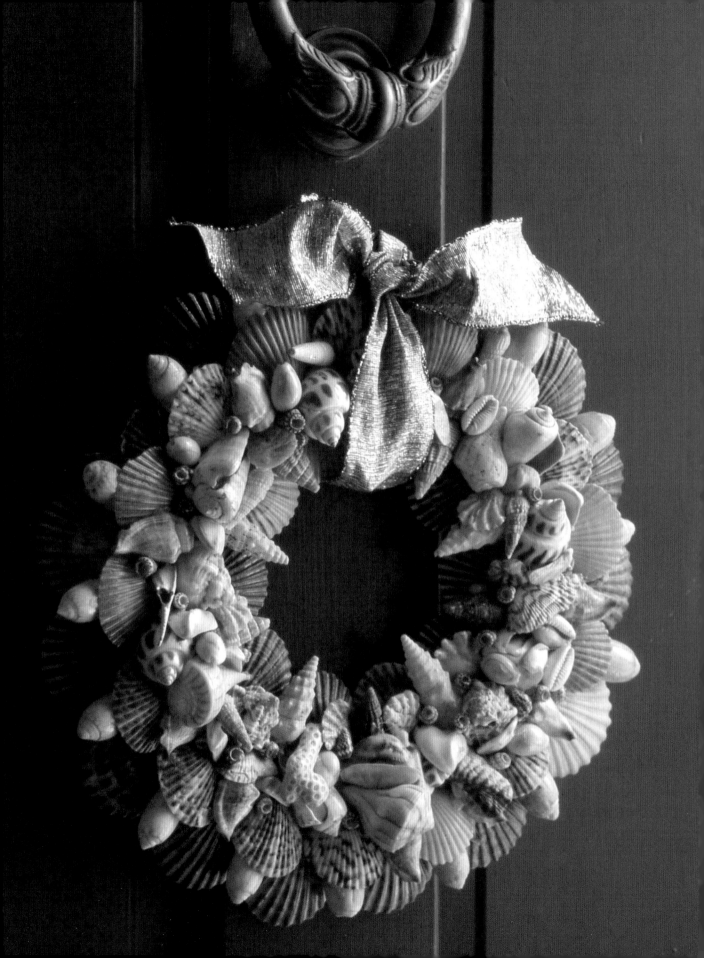

Scalloping

Scalloping is big business on Nantucket in the winter months. Families scallop either from boats or from land, wearing waders into the water and raking the scallops into baskets. Crafters like to use the discarded scallop shells for making tree lights or ornaments. Discarded scallop shells are also often used to make a Nantucket-themed decorated wreath.

LEFT: The wreath on my front door is made from a variety of shells found on my favorite beaches. All you need to create a similar one of your own is a bunch of shells, a wreath form (from a garden center), and a glue gun.

ABOVE: Scallop tree lights are popular items sold at the Christmas Stroll Craft Fair at Preservation Hall or The Methodist Church, both on Centre Street.

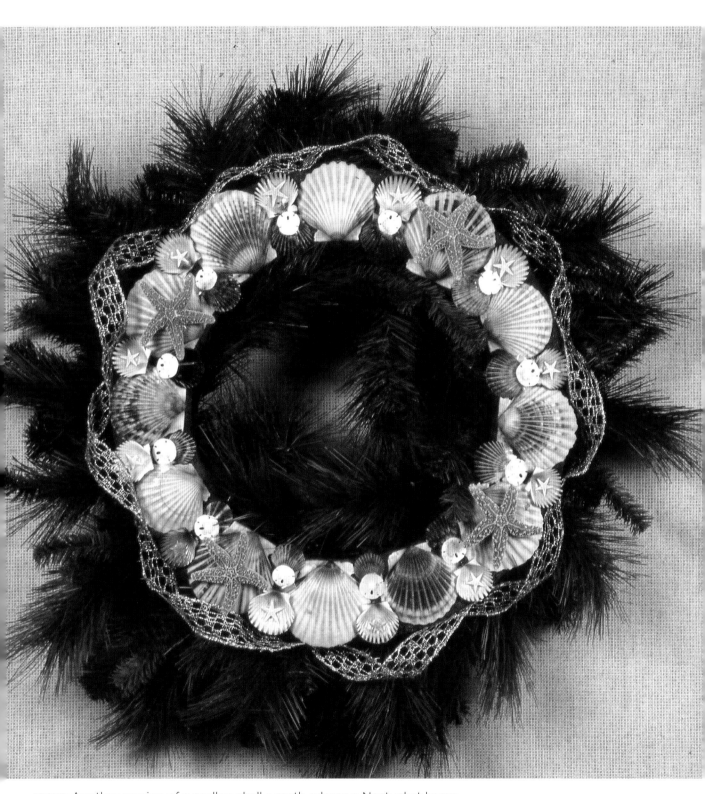

ABOVE: Another version of a scallop shell wreath adorns a Nantucket home.

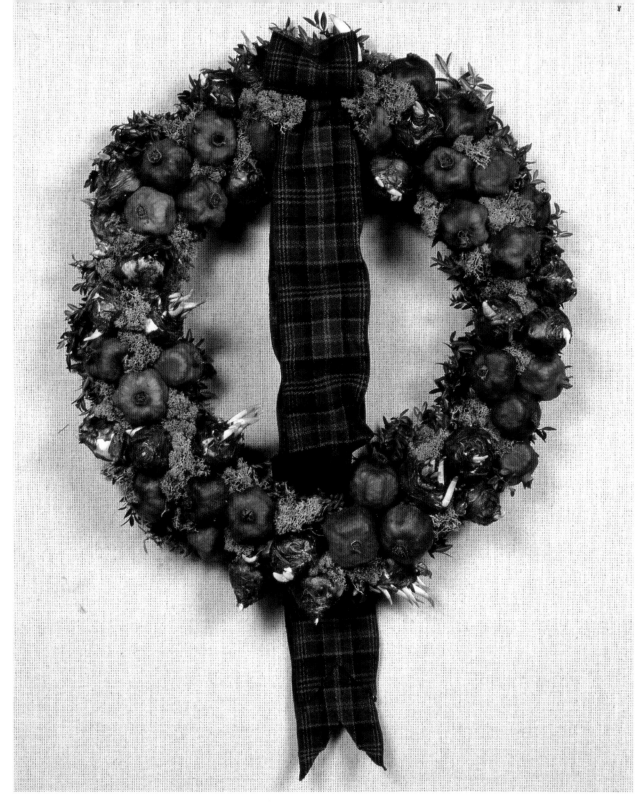

ABOVE: The Festival of Wreaths showcases beautifully designed wreathes, including this one, called Pomegranate and Greens.

RIGHT: Hydrangeas bloom all over the island during the spring, summer, and part of the fall. Locals cut and dry the blossoms to use on wreaths.

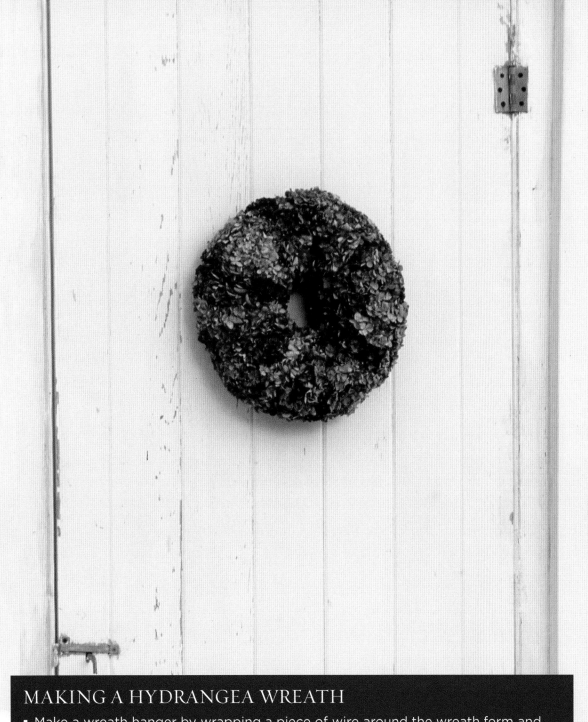

MAKING A HYDRANGEA WREATH

- Make a wreath hanger by wrapping a piece of wire around the wreath form and twisting it into a loop at the top.
- Hold the blossom in one hand and scrunch it up so the stem is exposed.
- Place the blossom on the wreath form and pin it in position with a florist's pin. Clip the excess end of the stem.
- Continue to add blossoms to the wreath as tightly packed together as possible.

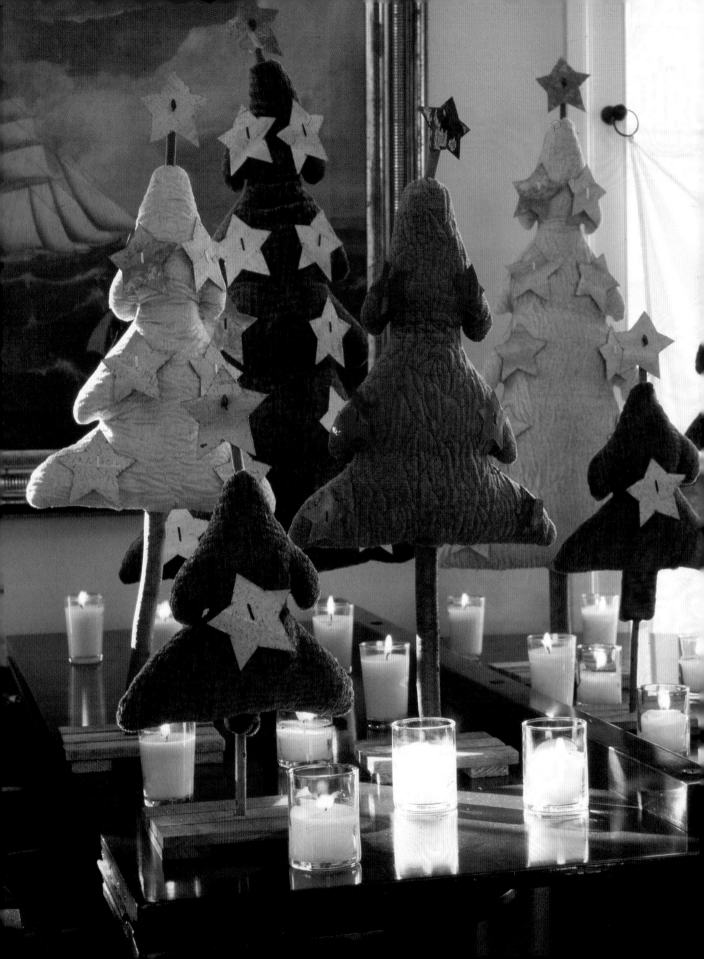

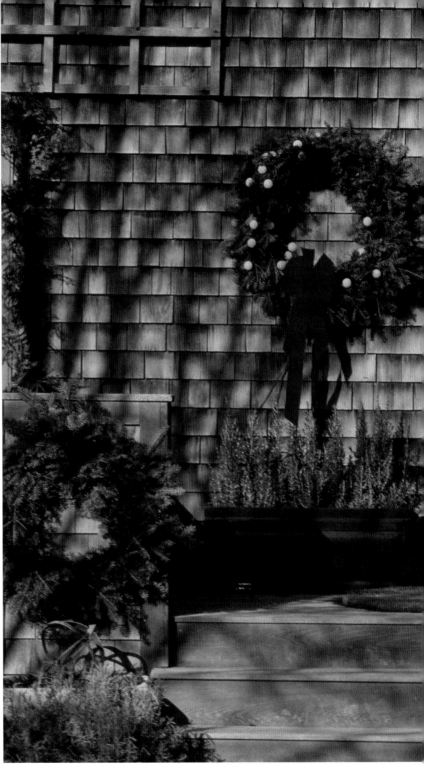

ABOVE: Simple green wreaths against gray shingles welcome visitors at Christmastime to the home of Kendra Lockley.

LEFT: A bevy of handmade felt trees creates a winter scene with lots of candles on top of a piano.

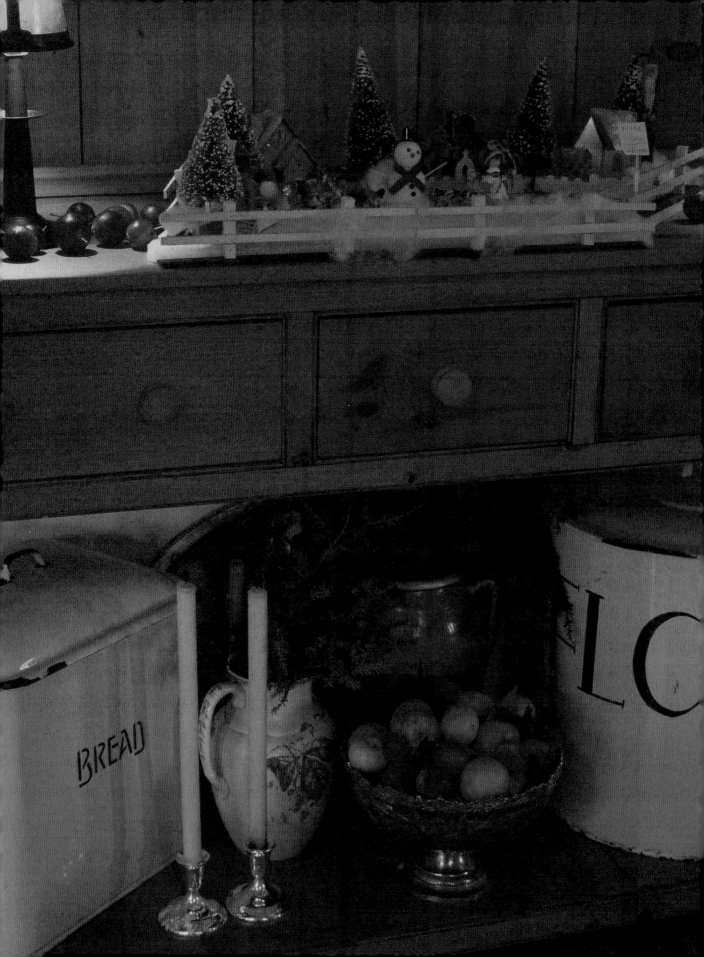

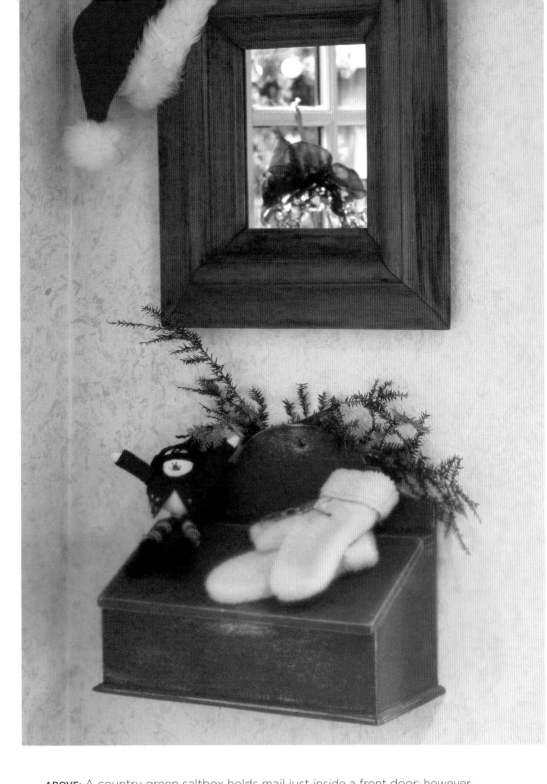

ABOVE: A country green saltbox holds mail just inside a front door; however, the forgotten mittens, glasses, and hat suggest a recent visit from Santa.

LEFT: A sideboard is decked out with a sweet, homey scene by Kendra Lockley and daughter Merrill.

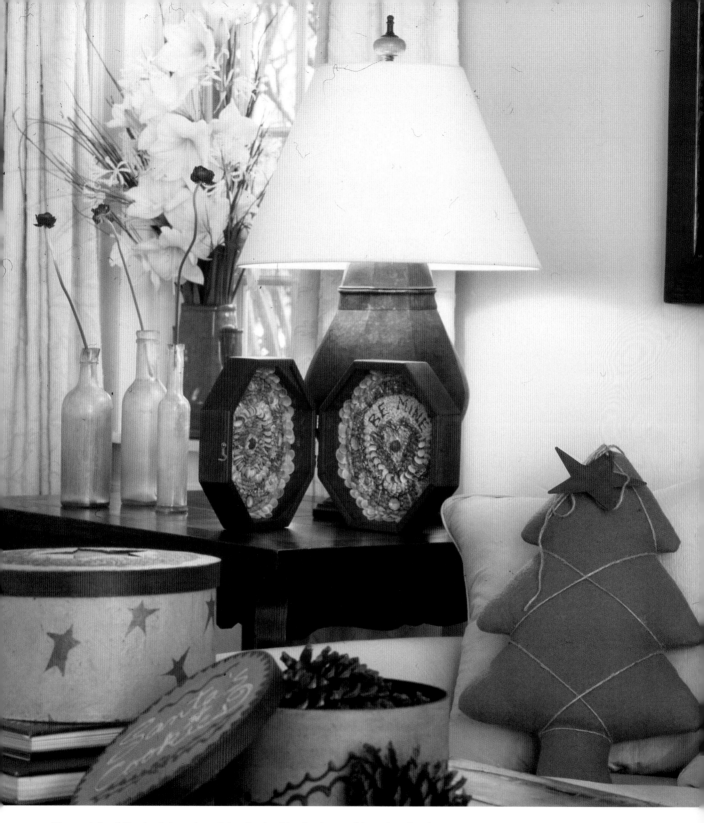

The spirit of the holidays is celebrated with displays of handcrafted objects, such as the sailor's valentine, a tree-shaped felt pillow, and stenciled hatboxes filled with giant pinecones.

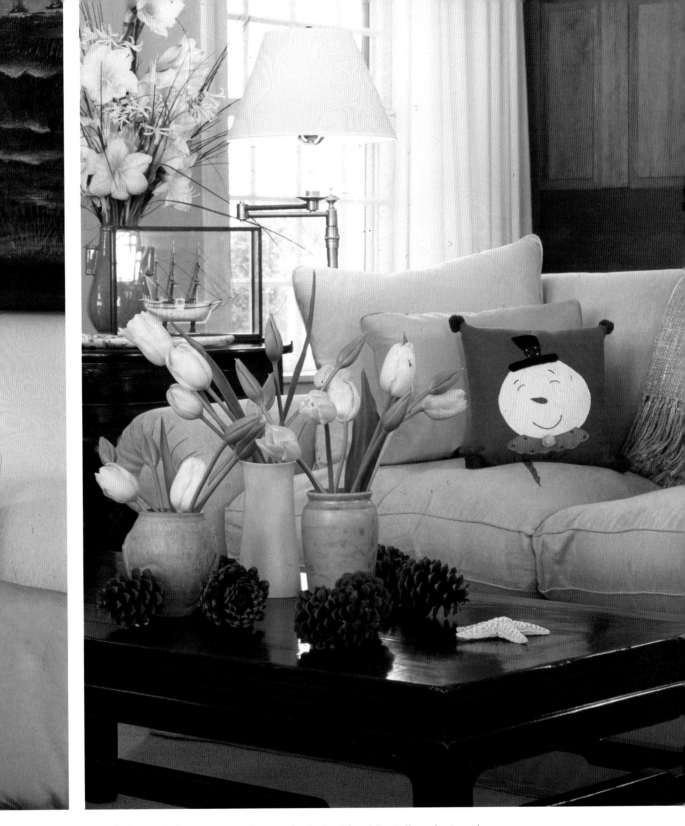

Simplicity and elegance are demonstrated with white tulips clustered
in three vases, tall white lilies on the side table, and green leaves
punctuating the snowy-white environment. The snowman pillow adds
a note of whimsy as do a few scattered pinecones.

Baking Cookies: A Time-Honored Tradition

Baking cookies is a holiday tradition in many homes and islanders enjoy these homey activities. No one does it better than Kendra Lockley, a famed caterer for many years of intimate dinner parties as well as fundraising events. She is known for her Nantucket-style, elegant interpretations of everyone's favorite dishes. Since her daughter was a little girl, (she's grown up now) they have been baking sugar cookies to give as gifts. Lockley says, "The recipe I use is a time-honored one that everyone probably has in their collection. It's nothing special, but we like it and we make it special with the cookie cutters we use (oversized) and the way we decorate them. Anyone can make them and they are always appreciated gifts." Wrapping the cookies in little cellophane bags with raffia or ribbon ties turns them into individual gifts for hostesses, teachers, or to use as tree decorations. Fill a basket with wrapped cookies to hand out to your party guests as they leave.

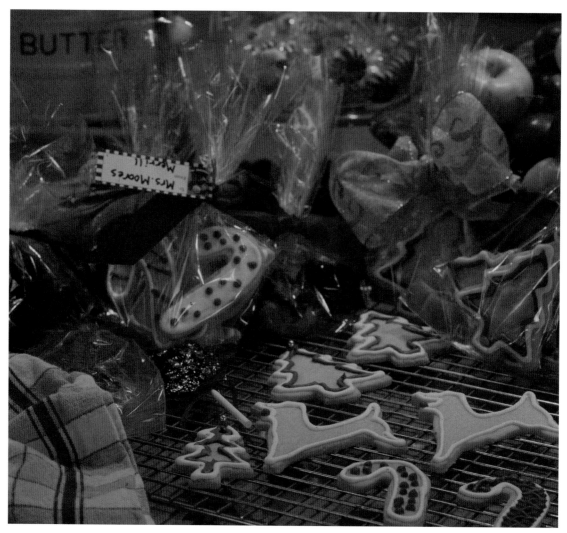

Kendra's sugar cookies are decorated and wrapped for gift giving.

KENDRA'S SUGAR COOKIES

EACH BATCH MAKES 24 TO 30 COOKIES

For the cookies

2 cups sifted all-purpose flour

¼ teaspoon salt

½ teaspoon baking powder

1 stick unsalted butter

1 cup sugar

1 large egg

1 teaspoon pure vanilla extract

1 teaspoon fresh lemon zest

½ teaspoon fresh lemon juice

For the icing

1 cup confectioner's sugar

1 tablespoon lemon juice

Food coloring

Set oven to 350ºF.

For the cookies

Sift together flour, salt, and baking powder. Set aside.

In a mixer, cream the butter and add sugar. Beat on medium speed for five minutes. Add egg, vanilla, lemon zest, and fresh lemon juice and beat on low, occasionally scraping down the bowl until thoroughly creamy.

Add flour mixture all at once and beat on low until incorporated.

Take dough out of bowl and flatten into a disc. Divide the dough in half for two batches and place in separate plastic bags. Refrigerate for an hour.

Lightly flour dough and roll out to a quarter-inch thickness. Cut into cookie shapes and place on an ungreased cookie sheet.

Bake for 8 to 10 minutes so cookies are light, not browned. (Kendra says the decoration is prettier this way.)

For the icing

Mix together confectioner's sugar and lemon juice, adding food coloring a little at a time until the desired color is reached.

Using Collections

Nantucketers have a history of collecting items to display in their homes. Whatever you collect, use them during the holidays to set an interesting table or create a "tablescape" in your entryway.

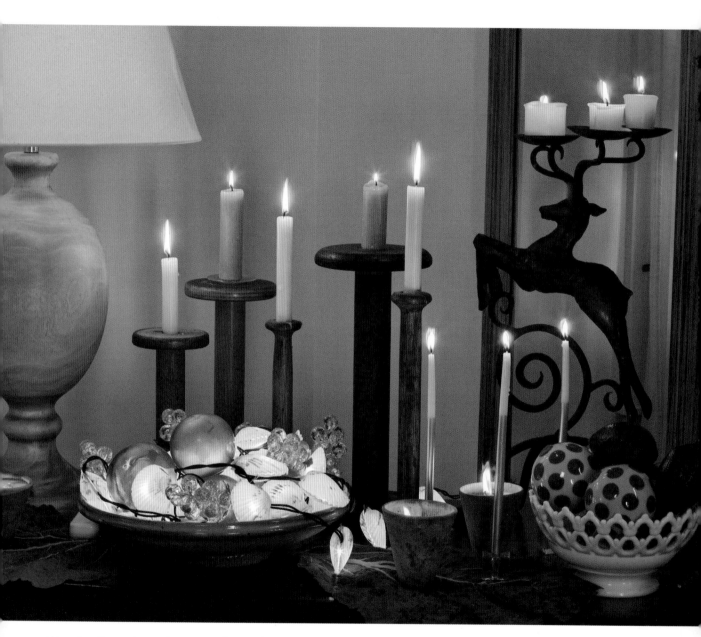

Wooden thread spools grouped together as candlesticks, a bowl of scallop lights, and a milk glass bowl with glass balls create a festive grouping on a side table.

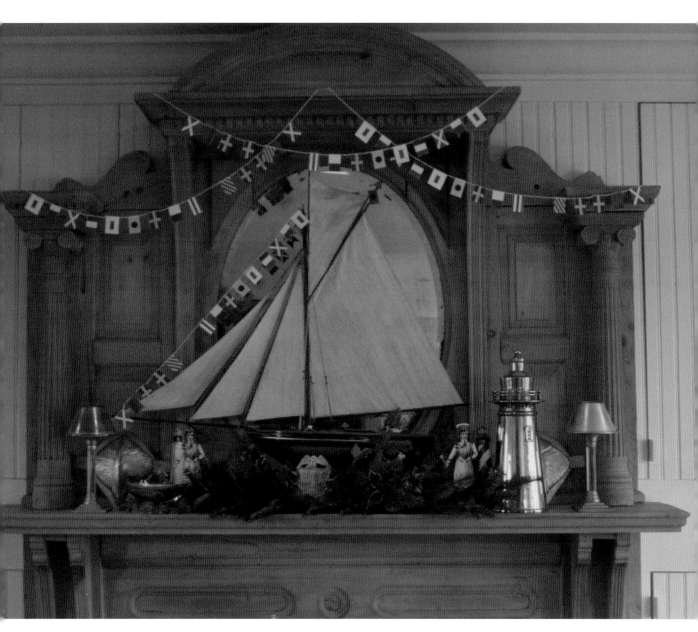

If you're a boating enthusiast you'll appreciate designer George Davis's holiday interpretation. A pond model sits on an English cabinet, surrounded by greens and nautical touches. George colored little paper, boat-signal flags that spell out "Merry Christmas" and attached them to the strings to create a unique decoration in the Nantucket boating tradition.

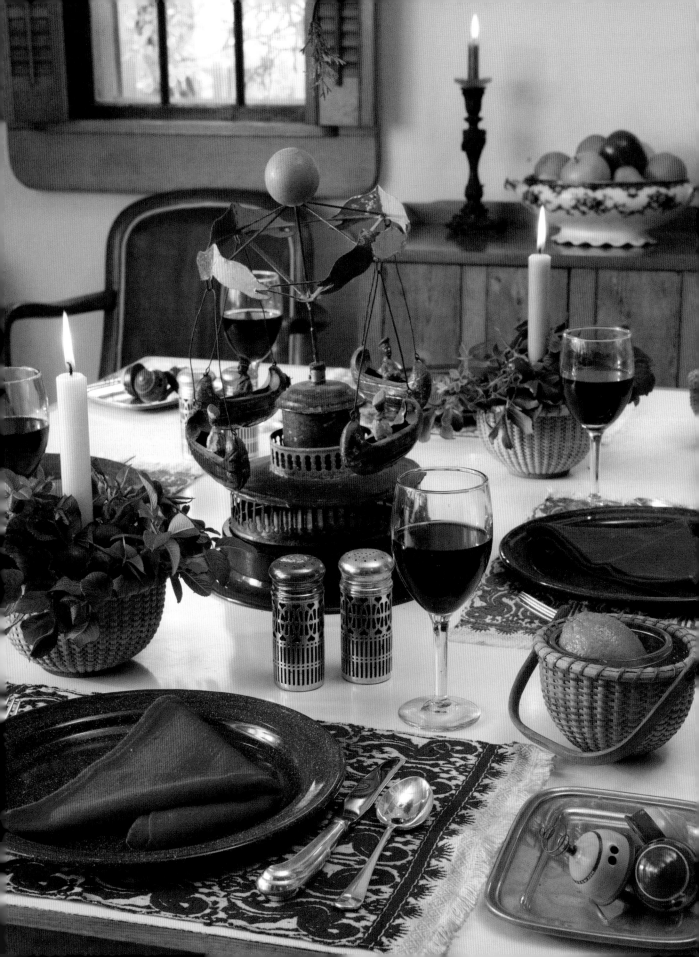

A BRIEF HISTORY OF VINTAGE ORNAMENTS

The golden age of Christmas ornaments dates between 1930 and 1940. Glass ornaments like the pinecone often hung on trees, along with real ones. Glass Santa heads were made in the 1930s from a clay or wooden mold, but the Santa doll head with the cone head was probably from a later era. In the 1880s Woolworth's sold imported ornaments from Germany for reasonable prices. Many of these extremely fragile pieces are still intact, as they were carefully packed away most of the year, and are now considered very collectible. Newer versions were made to look like the earlier ones, but the glass is much lighter.

Eggshell-thin, mold-blown silver and gold glass ornaments of detailed figures, fruits, and animals were very popular in the 1900s. Before 1940 these ornaments, mostly from Germany, were mouth-blown, then silvered, dyed, and decorated by hand and topped with a tin or steel cap.

Wax angels were also imported from Germany before 1929. They were popular items in the 1926 Sears, Roebuck, and Co. catalog.

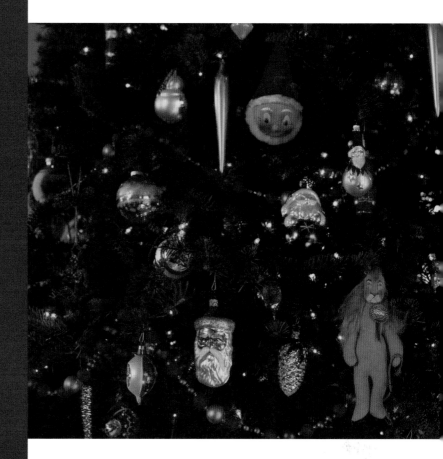

ABOVE: Kathleen Welsh-Young, owner of Old Spouter Gallery on Orange Street, decorates her tree each year with her childhood collection of vintage ornaments. There are molded shapes and soft sculptures like the lion with his "Courage" badge from the *Wizard of Oz.*

FAR LEFT: My friend Donn Russell is an artist with a sense of humor and often creates whimsical displays. Here he's used his collection of small lightship baskets to hold holly, candles, and fruit. He chose a musical toy merry-go-round for his centerpiece. Three colorful tops are set on a silver tray.

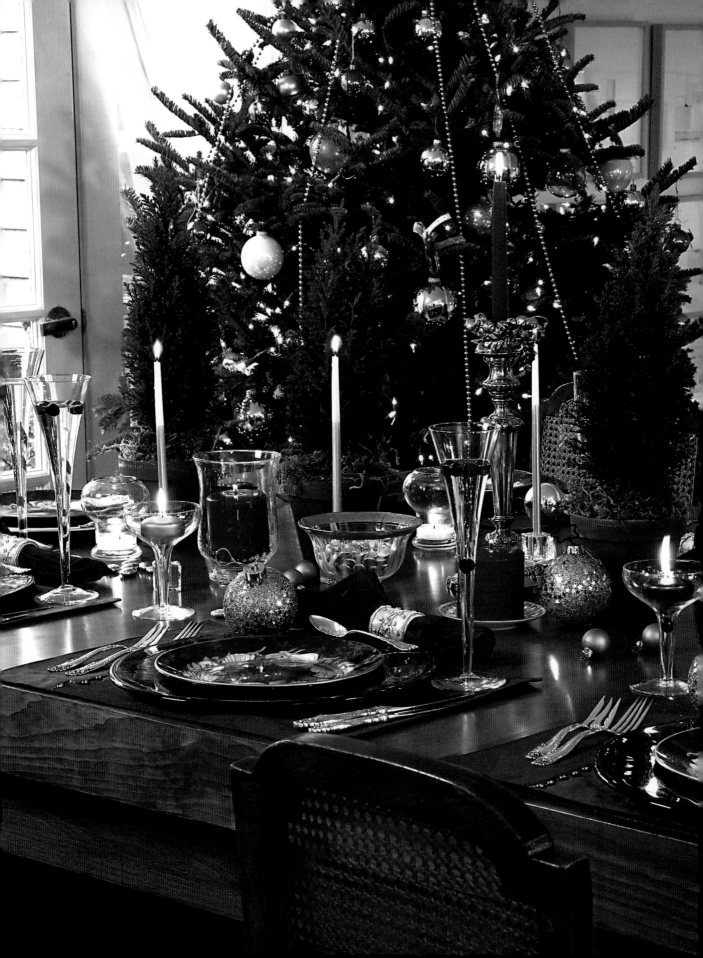

HOLIDAY
ENTERTAINING
NANTUCKET STYLE

M aking a meal, setting a table, and entertaining friends are part of what makes the holidays a special time for most of us. Setting a beautiful table makes guests feel celebrated, and Nantucketers pride themselves at doing this well. I bring out everything I love for setting a holiday table and make it as lavish and festive as possible.

NANTUCKET CHRISTMAS TART

For the short pastry

2 cups pastry flour, sifted

⅔ teaspoon salt

½ cup shortening

6 tablespoons water

For the filling

¾ pound almond paste

¾ pound granulated sugar

5 egg whites

5 Anjou pears, peeled, cored, and halved.

Preheat oven to 375ºF.

To make the short pastry

Sift together the flour and salt. Cut in half of the shortening, blending thoroughly. Add remainder of shortening and work to a pebbly stage.

Add water, one tablespoon at a time.

Form the dough into a ball, place in a plastic bag, and chill for one hour. Roll out the dough and press into a 12-inch flan ring.

For the filling

Mix together the paste, sugar, and egg whites, and pour into pastry shell.

Arrange pears, cored side down, on top of the filling.

Bake for 45 minutes.

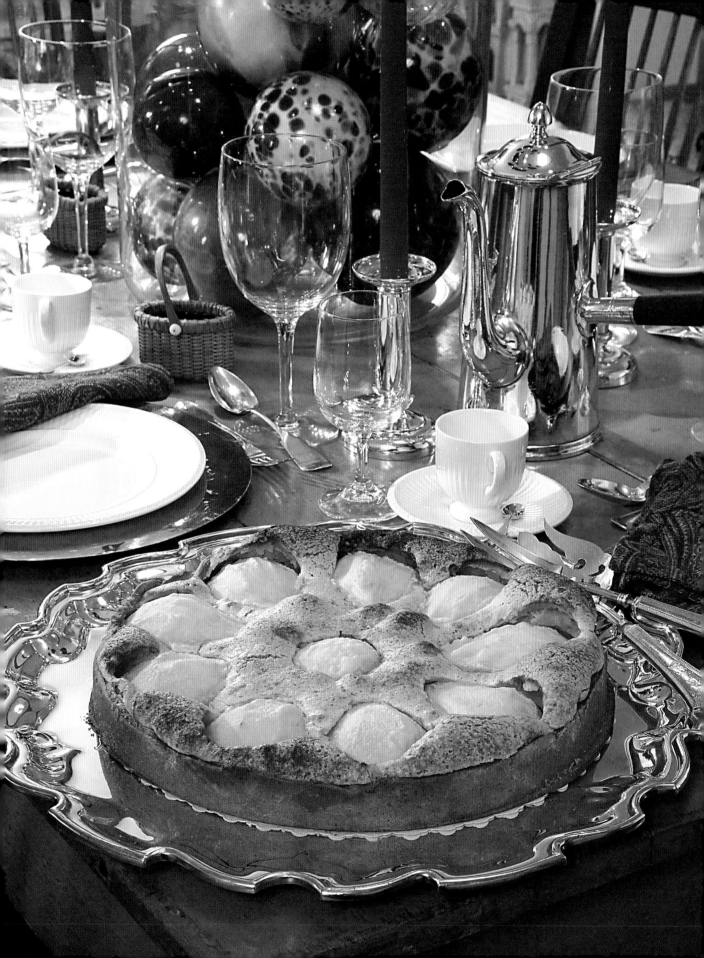

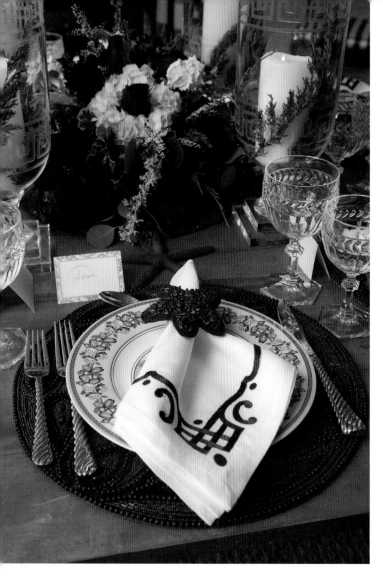

ABOVE: When setting a holiday table, bring out all your best chinaware, glassware, silverware, and linens. Here, sprigs of greens are inserted into the etched hurricane lamps that hold battery-operated candles, and the centerpiece of greens and red and white roses is low enough to see over when guests are seated. A red fabric starfish napkin holder, red beaded placemats, and painted starfish create a lush place setting.

RIGHT: A cheerful dining room in an 1800 house on Union Street is ready to receive guests.

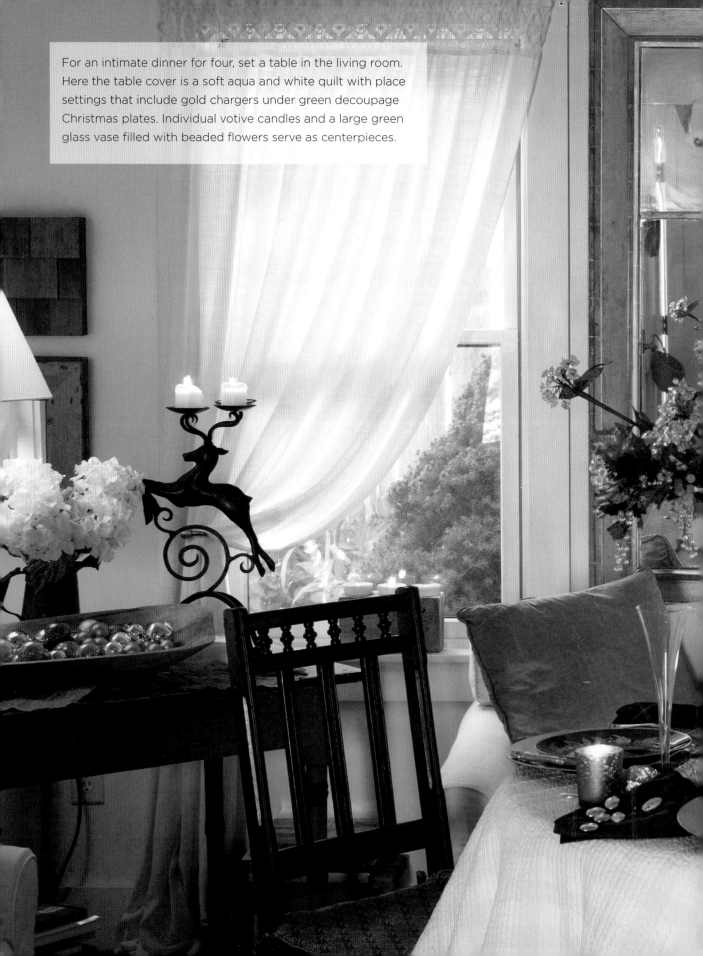

For an intimate dinner for four, set a table in the living room. Here the table cover is a soft aqua and white quilt with place settings that include gold chargers under green decoupage Christmas plates. Individual votive candles and a large green glass vase filled with beaded flowers serve as centerpieces.

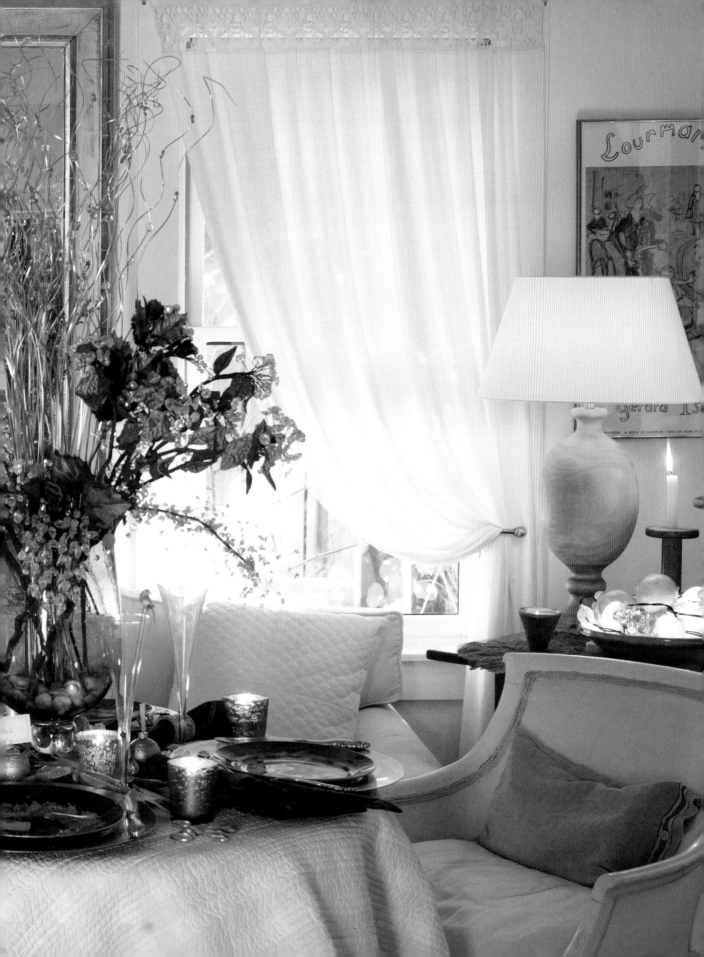

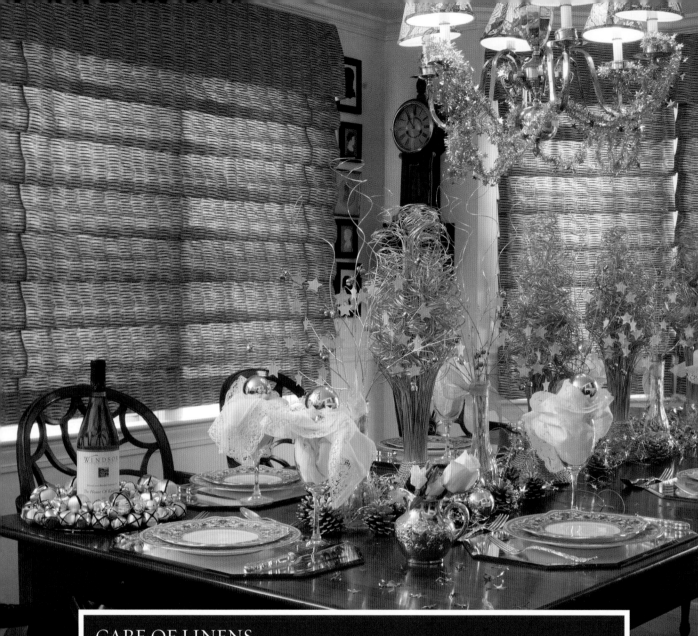

CARE OF LINENS

To freshen linens that have been stored away for months, wash them and then let them air dry until slightly damp. Press the linens on the wrong side while damp. A little bit of spray starch while ironing will bring back crispness.

If a guest spills coffee on your best linen tablecloth, quickly rinse with boiling water before washing. Rub salt into fruit stains, then soak in cold water and wash in cold water as well. If someone spills wine, immediately douse with seltzer, or pour salt on the stain until you have a chance to wash the linens.

To store linens until next year, always wrap them in blue tissue or acid-free paper for protection from daylight damage. White tissue lets light in, which causes yellowing. Store in a dry place with good air circulation. Unbleached muslin is also a good material for wrapping linens.

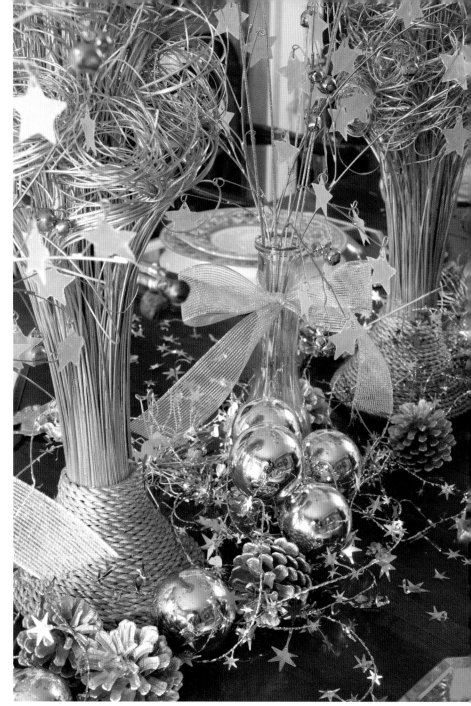

A sparkling table is set for twelve in a formal dining room on Cliff Road. The hostess entertains often and is known for her creative table settings. For Christmas Eve, the table is set to glitter with an all-silver theme.

The hostess likes to mix decorations found in discount stores, with her antique plates and ornate silver just for fun. Tall glass vases are filled with strands of glitter and tied with sheer silver ribbon. Silver balls, spray-painted pinecones, and silver garlands are strewn down the middle of the table. For such a long table, you need more than one center bouquet. Lace-edged linen napkins are set into wine goblets and a silver Christmas tree ball indicates the seating arrangement.

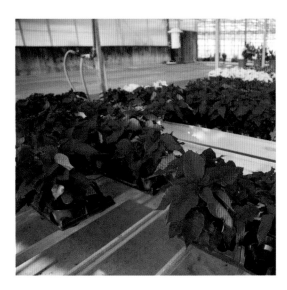

Poinsettias fill the greenhouses at Bartlett's Oceanview Farm during the holidays. In the summer they are replaced with geraniums and impatiens.

POINSETTIA TRIVIA

Although the poinsettia plant is indigenous to Mexico and Central America, it has become the symbol of Christmas all over the United States. These are warm-weather plants that favor moist, well-drained soil and plenty of indirect sunlight.

THE AMARYLLIS

The amaryllis is an elegant Dutch plant that flowers the last week of November and lasts right through New Year's Day and beyond. It is a favorite, along with the poinsettia, as a Christmas flower. Amaryllises have huge trumpet-like blossoms in soft pink, white, or bright red. A bulb can produce up to four flowers on each of two stems. They are easy to grow because they only need warmth, water, and light.

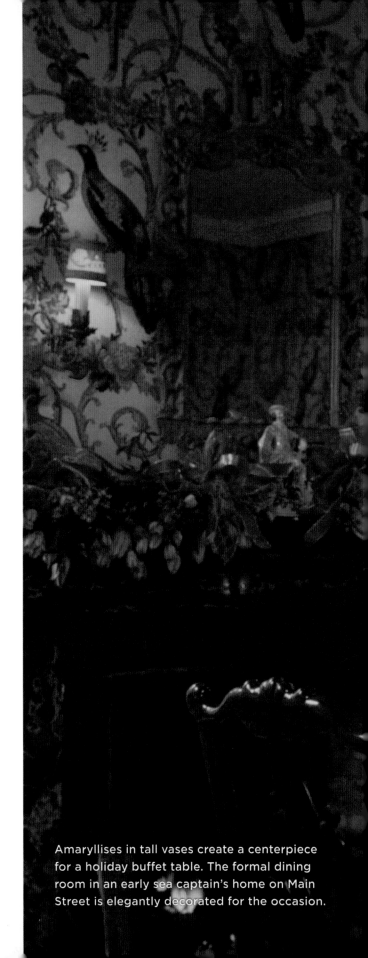

Amaryllises in tall vases create a centerpiece for a holiday buffet table. The formal dining room in an early sea captain's home on Main Street is elegantly decorated for the occasion.

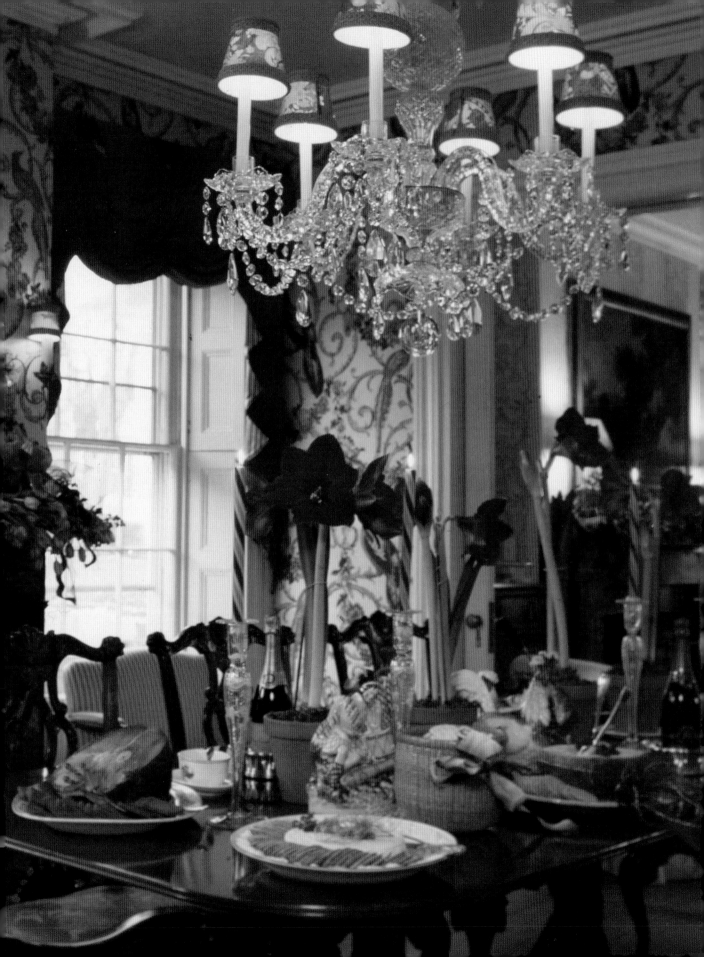

About the Author

Leslie Linsley is the author of more than seventy-five books on decorating, crafts, and lifestyle, including *Nantucket Island Living, Nantucket Cottages & Gardens, Salvage Style*, and *Upscale Downsizing*. She lives on Nantucket Island and writes regular columns and lifestyle articles for the *Nantucket Inquirer & Mirror* newspaper, *Nantucket Today* magazine, and the *Key West Citizen*.

About the Photographers

Photographers Jeff Allen, Cary Hazelgrove, and Terry Pommett are year-round island residents whose work is seen regularly in national publications. Jon Aron, a nationally known photographer and graphic designer, has collaborated with Leslie Linsley on more than thirty books.

ACKNOWLEDGEMENTS

I'd like to thank my editor, Amy Lyons, for making this a delightful project beginning with our first meeting in New York. She was on the island staying with her family during Christmas Stroll and it was so enjoyable sharing the experience with her. Also, and always, my hard-working agent, Linda Konner who goes over the top on my behalf. She's a true professional, but also a good friend.